MW00564194

IMAGES
of Aviation

FAIRCHILD
AIRCRAFT

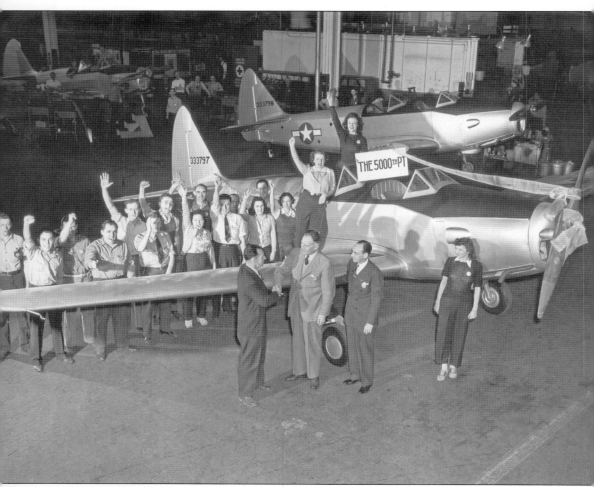

With the threat of World War II looming, the demand for Fairchild's primary trainer skyrocketed. From 1938 to 1944, the company built more than 7,000 trainers for the U.S. Army Air Force and other allied nations. A special ceremony was held in 1943 in recognition of the 5,000th PT built by Fairchild. Pictured in the cockpit is Evelyn Leisinger. Standing in front of the plane are, from left to right, Frank Revell, Paul Frizzell, Arthur F. Flood, and Mary Gossard Grove. Behind the wing from left to right are Red Cain, Bob Miss, unidentified, Rollo Mowen, two unidentified, Johnnie Wingert, Pauline Bitner, unidentified, Ralph Faulders, unidentified, Anna Langstein, unidentified, Mary Mumma, and Reatha Harrell. (Courtesy Ed Leisinger.)

ON THE COVER: The first production C-82 rolled off the assembly line at Fairchild's Plant No. 3 in Hagerstown, Maryland, and moved onto the apron on Tuesday, May 15, 1945. Known as Packet No. 1, the fuselage of the plane went into the main assembly jig in September 1944. In January 1945, the fuselage moved to the experimental area in Plant No. 4, where the center section, landing gear, booms, and tail assembly were added. It was on March 2 that the airplane went into final assembly. With the massive nose section and its engines as a backdrop, some of the people who helped build the cargo plane pose for a historic photograph. (Courtesy Donna Unger.)

IMAGES
of Aviation

FAIRCHILD
AIRCRAFT

Frank and Suanne Woodring

ARCADIA
PUBLISHING

Copyright © 2007 by Frank and Suanne Woodring
ISBN 978-0-7385-4439-7

Published by Arcadia Publishing
Charleston SC, Chicago IL, Portsmouth NH, San Francisco CA

Printed in the United States of America

Library of Congress Catalog Card Number: 2006941028

For all general information contact Arcadia Publishing at:
Telephone 843-853-2070
Fax 843-853-0044
E-mail sales@arcadiapublishing.com
For customer service and orders:
Toll-Free 1-888-313-2665

Visit us on the Internet at www.arcadiapublishing.com

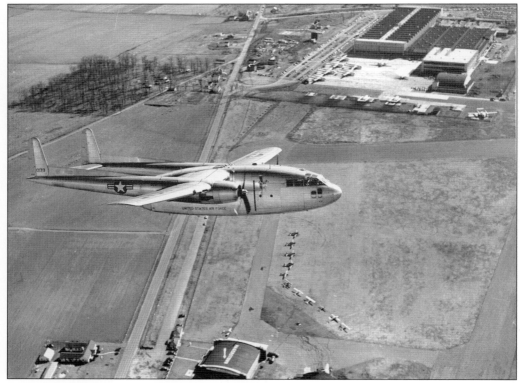

A C-119 flies over the Hagerstown Municipal Airport near the main Fairchild plant along Route 11, north of Hagerstown. In the lower left corner of the picture is the Air View Restaurant and Motel. Nearby was the Always, a restaurant that opened in the 1930s to serve pilots. The Always later became the Airport Inn, which was purchased by Nick Giannaris in 1961. It is still a popular dining site. More than 1,000 C-119s were built at the Fairchild plant seen in the background. (Courtesy Merle Barnhart.)

CONTENTS

Acknowledgments 6

Introduction 7

1. Aviation Giant Springs Forth 9

2. "Community" Effort Spawns Growth 23

3. Global Unrest Propels Future 39

4. Legacy Attributed To Faircrafters 73

ACKNOWLEDGMENTS

We wish to sincerely thank the more than 70 groups or individuals who contributed to making *Fairchild Aircraft* possible. Without each one, this testimonial to the men and women who worked for the aircraft manufacturer would not have been possible. We want to thank those individuals from all across the country who graciously shared their valuable Fairchild memorabilia with us. We were pleasantly surprised that they would part with such a wealth of material with no strings attached—"Keep it as long as you need it." These donors include Merle Barnhart, Tallahassee, Florida; Meredith Darlington, St. Joseph, Missouri; Bob Fabris, San Jose, California; Colleen Heuser, Louisville, Kentucky; John Kreigh Jr., Hagerstown, Maryland; Ed Leisinger, Mercersburg, Pennsylvania; Eloise Shaffer, Hagerstown, Maryland; and Danny Shindle, Williamsport, Maryland.

Robert Kefauver and Dave Verdier, two individuals who have no direct ties with Fairchild except for their intense interest in aviation, were invaluable in sharing their wealth of knowledge on aircraft. Their enthusiasm in this project was an inspiration when it appeared the task was insurmountable. While a senior at South Hagerstown High School in 1968, Kefauver wrote a detailed history of Fairchild Aircraft. "Wings over Hagerstown," a paper written by Maryland delegate Chris Shank while an undergraduate student at Johns Hopkins University in 1993, provided a glimpse of the socioeconomic impact of Fairchild on Hagerstown and Washington County during World War II.

Those groups that opened up their Fairchild archives with us include Doug Bast of the Boonesborough Museum of History, Kurtis Meyers and John Seburn of the Hagerstown Aviation Museum, Ann Hull of the Franklin County Historical Society, John Frye of the Western Maryland Room of the Washington County Free Library (noted as WMR in courtesy lines), the Washington County Historical Society (noted as WCHS in courtesy lines), and the *Maryland Cracker Barrel* magazine.

We want to recognize Kent A. Mitchell, whose book *Fairchild Aircraft 1926–1987* is an aviation classic, for his willingness to share with us. Fred Kuhn, a former Fairchild pilot, was of vital assistance in providing technical support. Numerous visits with former Fairchild employee Preston Buck gave us an insight into some of the behind-the-scene stories relating to the aviation giant.

One of the many rewarding aspects of gathering material for *Fairchild Aircraft* was a visit with former Fairchild president Ed Uhl at his Oxford, Maryland, area home. Having never met him previously, Uhl proved to be a gracious host while offering us his Fairchild archives.

Our project would have been extremely difficult without the assistance of Eric Munch, who worked at Fairchild, as did his father, Marvin Munch. Their collection of *FAD* and *Pegasus* magazines enabled us to identify numerous photographs that had been donated but without identification. The majority of pictures given to us were done professionally by numerous Fairchild photographers. *FAD* and *Pegasus* magazines were published by Fairchild itself and contained many of the same pictures we used along with vital information regarding them.

We dedicate this book to Clare Preston Woodring, a granddaughter whose irresistible smile and bubbly personality brightened each day and lightened our steps as we compiled this tribute to the many Faircrafters who built aircraft that helped preserve the freedoms America stands for.

INTRODUCTION

In 1903, when brothers Orville and Wilbur Wright proved that man could make a "flying machine," the population of the Western Maryland community of Hagerstown was less than 15,000 people. Less than 50 years later, Hagerstown, known as the Hub City partly because of the convergence of four major railroads, had become known throughout the world for its prowess as an aircraft manufacturer.

The city's meteoric flight into the field of aviation actually began several years after Italian immigrant Giuseppe Bellanca arrived in the United States. In 1916, Maryland Pressed Steel Company, formerly the Pope Manufacturing Company on Pope Avenue in Hagerstown, hired Bellanca to design and build the company's first airplane. The same year, Bellanca successfully piloted the Bellanca C.D., the first aircraft built in Hagerstown, from Doub's Meadows, today the site of South Hagerstown High School.

In 1921, Lewis Reisner, who had worked with Bellanca at Maryland Pressed Steel, founded Reisner Aero Service, a company that serviced and sold aircraft. Four years later in 1925, Reisner and Ammon Kreider, a local shoe manufacturer, formed the Kreider-Reisner Aircraft Company on Pennsylvania Avenue in Hagerstown. The following year, the new company built the KRA Midget, a small racing plane that won the Scientific American Trophy Race held in Philadelphia in September 1926.

As a result of national recognition achieved with the win in Philadelphia, Kreider-Reisner began manufacturing the Challenger, which became one of the most popular aircraft used by sport plane enthusiasts in the 1920s. The success of the Challenger captured the attention of Sherman Mills Fairchild, an aviation entrepreneur who was producing the first commercially successful cabin monoplane in Farmingdale, Long Island, New York. In the spring of 1929, Fairchild acquired 82 percent of the common stock in Kreider-Reisner, making the Hagerstown company a subsidiary of the Fairchild Aviation Corporation, which eventually became Fairchild Aircraft Company.

Sherman Fairchild had devised the world's first between-the-lens shutter for aerial cameras, making accurate aerial mapping possible. On February 9, 1920, Fairchild established the Fairchild Aerial Camera Corporation at the age of 24, and his interest in aerial photography led him into the design and manufacture of aircraft before acquiring controlling interest in Kreider-Reisner.

When the United States was drawn into World War II following the bombing of Pearl Harbor in December 1941, Hagerstown's role in aviation history was guaranteed. Fairchild's M-62, later designated the PT-19, became the first monoplane to be designed exclusively for the training of pilots. Employing the "Hagerstown System," which incorporated the use of more than two dozen plants in the city in the production of aircraft, Fairchild manufactured approximately 1,200 PT-19 trainers from 1941 to 1944. The number of Fairchild employees in 1939 numbered around 200, but by 1943, there were 8,000 workers involved in Hagerstown's aviation contribution to the war effort.

When V-J Day officially signaled the end of World War II on August 15, 1945, the United States military had already begun preparations for the ensuing cold war that would follow. In 1945, Fairchild began the delivery of the C-82 Packet, a large capacity cargo aircraft. By September

1948, the Hagerstown company had built 223 C-82s. In the early 1950s, the number of Fairchild employees reached approximately 10,000 men and women, who teamed up to manufacture 1,112 C-119s between 1948 and 1952. Affectionately known as the "Flying Boxcar," the C-119 was an adaptation of the C-82. The plane was used by the military in both the Korean War and the war in Vietnam.

A last-minute bid by Fairchild for a contract to build 165 C-123 aircraft was accepted by the U.S. Air Force in 1953. When C-123 production ceased on July 31, 1958, Fairchild had built 303 of the aircraft, 138 more than the original contract called for.

On June 22, 1958, the first of 207 F-27s and FH-227s was delivered by Fairchild. The F-27 Friendship had been developed originally by Fokker in Holland, but an agreement with Fairchild in 1956 gave the U.S. company the rights to build and market the passenger plane in the Western Hemisphere.

In 1974, Fairchild was the recipient of a U.S. Air Force contract to produce the A-10 Thunderbolt. Scoffed at by many as an "ugly" plane, the "Warthog" displayed its value to the military in dramatic fashion with its performance in the Gulf wars. Sadly, when the last of 713 A-10s was handed over to the U.S. Air Force on March 20, 1984, it marked the end of aircraft manufacturing in Hagerstown and Washington County.

Families and communities throughout the Tri-State area of Maryland, Pennsylvania, and West Virginia were bonded together by employment at Fairchild Aircraft. It is estimated that more than 50,000 individuals were employed at one time or another by the aircraft manufacturer.

For the sake of simplicity, in Images of Aviation: *Fairchild Aircraft*, Fairchild is referred to as Fairchild Aircraft although at various times the Hagerstown facility was referred to by a variety of names.

One

AVIATION GIANT
SPRINGS FORTH

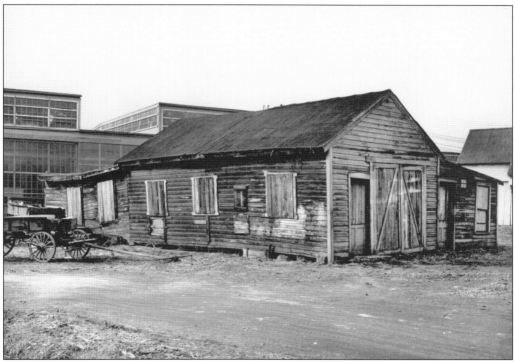

In 1925, Lewis E. Reisner and Ammon Kreider, a shoe manufacturer, formed the Kreider-Reisner Aircraft Company. In 1929, Sherman Fairchild purchased a controlling interest in Kreider-Reisner, which eventually became Fairchild Aircraft. This "Little Green Shed" off Pennsylvania Avenue in Hagerstown near present-day Park Avenue was part of the original Kreider-Reisner factory complex. (Courtesy WMR.)

Lewis Reisner, who had worked for Giuseppe Bellanca at the Maryland Pressed Steel Company on Pope Avenue in Hagerstown, formed the Reisner Aero Service in 1921 to do general repair work on aircraft. Bellanca had been hired by Maryland Pressed Steel to build that company's first airplane. The letterhead from Kreider-Reisner Aircraft is seen above. Reisner's signature is seen below from a letter that he had written in 1930 in reference to Kreider-Reisner employee Merle Shindle. Shindle, who spent 43.5 years as an employee of Kreider-Reisner and later Fairchild Aircraft, started as a bench welder in March 1929. In his letter Reisner noted, "Mr. Shindle's services have been satisfactory, and we can recommend him to anyone requiring a man of his experience." (Courtesy Danny Shindle.)

Very truly yours,

KREIDER-REISNER AIRCRAFT CO. INC.

L. E. Reisner

L. E. REISNER,
Vice President.

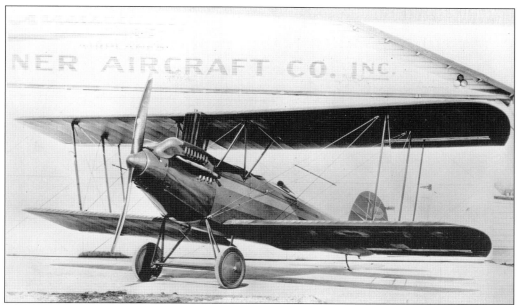

The C-2 (above), the second airplane in the Challenger series manufactured by Kreider-Reisner, sits in front of the wooden hangar at the airstrip that the company purchased in 1928 north of Hagerstown. Planes were built in the factory off Pennsylvania Avenue and trucked to the airstrip, where the wings were attached. Today the Hagerstown Regional Airport sits near the site of the original airstrip. The original Challenger flew in a promotional tour in 1927, but it was the credibility of the C-2 that launched Kreider-Reisner as a legitimate aircraft manufacturer. In 1926, Kreider-Reisner built another Challenger, designated the KR-31, a three-seat biplane (below). The open-cockpit plane was used primarily for sport flying. While attending the Second All-American Aircraft Show in Detroit, Michigan, Kreider was killed when his plane collided with another aircraft at the Detroit Ford Airport on April 13, 1929. (Courtesy WMR.)

The first Fairchild-designed airplane was the FC-1, built in Farmingdale, Long Island, New York, and towed 12 miles by truck to Roosevelt Field, where it made its flying debut in 1926. Designed as the aerial photographer's dream, the FC-1 was a three-seat, high-wing monoplane powered by an OX-5 engine with 90 horsepower that delivered a top speed of 97 miles per hour. Above, Dick Depew Jr. is at the controls of the FC-1. Fred Weymouth, a Fairchild engineer, is seated in the cabin, while C. M. Johnson is standing outside the FC-1, the first airplane with an enclosed cabin and folding wings. The plane was flown around the country in the Ford Tour of 1926 and entered in Philadelphia's air races. With the success of the FC-1 (below), Fairchild rented the Lawrence Sperry factory at Farmingdale in 1927, resulting in the advent of the Fairchild Aviation Corporation. (Courtesy WCHS.)

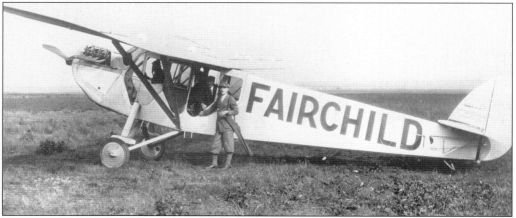

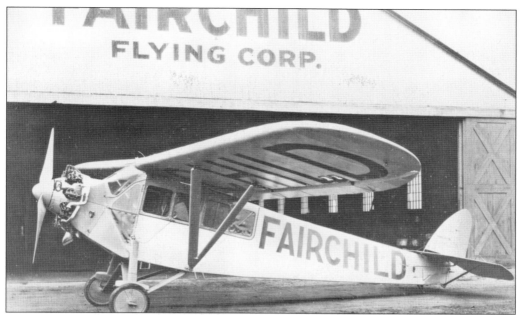

The FC-1 (above) was a prototype and never went into production. Its successor, the FC-1A, was powered by a Wright J-4 radial air-cooled engine with 200 horsepower capable of reaching a top speed of 120 miles per hour. Flown in 1927, the FC-1A was used extensively as an aerial mapping plane. It too was a prototype aircraft. Below, 30-year-old Sherman Fairchild (third from left in the beaver coat) is pictured with actress Gloria Swanson in 1927 when she helped christen the FC-1A at Roosevelt Field. Modifications to the FC-1 enabled the plane to be used in almost all of the first airmail runs in the United States. An advertisement for Fairchild's monoplane appeared in the May 1927 issue of *Aero Digest* and gave the name of the company as Fairchild Airplane Manufacturing Corporation in Farmingdale, Long Island. (Above courtesy WCHS; below courtesy WMR.)

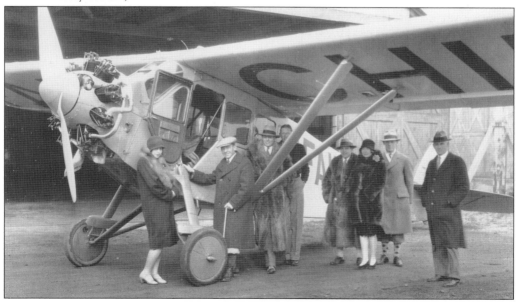

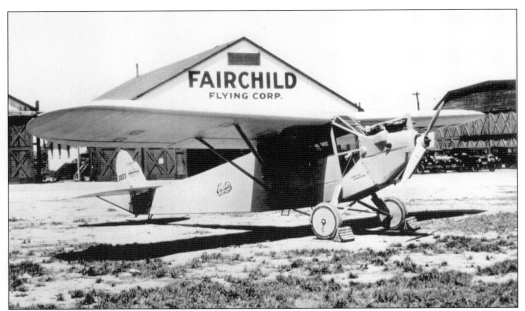

Fairchild's FC-2C was the first plane to carry international mail and was the first aircraft to be equipped with brakes and hydraulically operated landing gear. The FC-2 was powered by the Wright J-5, the same engine that powered Charles Lindbergh's *Spirit of St. Louis* in 1927 when the aviator became the first person to make a nonstop solo flight from New York to Paris. (Courtesy WMR.)

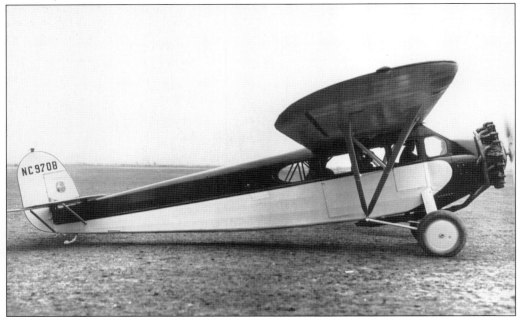

Model 71 was a modification of the FC-2W2 and was used to pioneer mail, express, and passenger service to the Northwest. Powered by a 410-horsepower Pratt and Whitney Wasp engine, a number of the planes were ordered by the U.S. Army Air Corps to be used as photographic planes. These craft were designated as the YF-1. (Courtesy WCHS.)

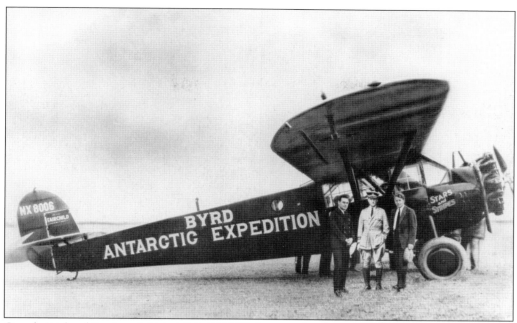

Comdr. Richard Byrd made Fairchild's FC-2W2 famous when he selected the plane as one of three airplanes used on the first flight to Antarctica in 1928. Named the *Stars and Stripes*, the FC-2W2 was the first plane to fly over that continent. In the above photograph, Commander Byrd (left) is pictured with pilots Harold I. June and Bernt Balchen. When Byrd returned to the United States, he left the *Stars and Stripes* (below) entombed in an igloo hangar. Upon Byrd's return to Antarctica in 1933, the FC-2W2 was serviced and used for aerial photography flights over the icy continent. The Fairchild aircraft logged almost 200 hours in Antarctica. In 1962, the *Stars and Stripes* was given to the Smithsonian Institution. (Courtesy WMR.)

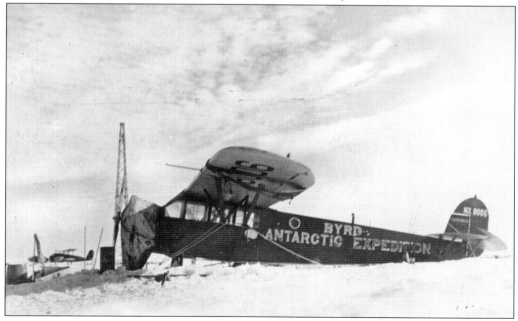

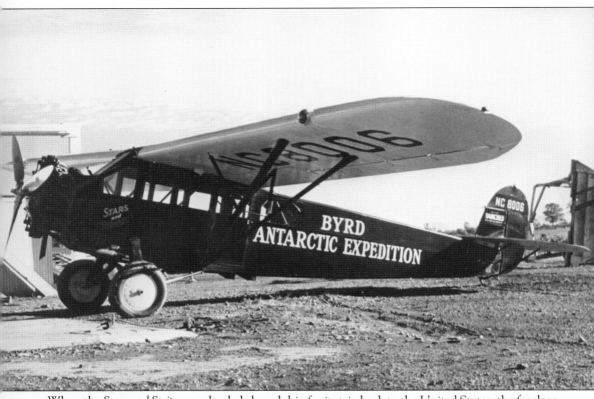

When the *Stars and Stripes* was loaded aboard ship for its trip back to the United States, the fuselage was severely damaged. Merle Shindle was one of the Hagerstown Fairchild workers who made repairs to the fuselage of the legendary FC-2W2 before it returned to service as a barnstorming ship, a crop duster, and an aerial photography plane. The *Stars and Stripes* eventually returned to Fairchild ownership before the company donated it the Smithsonian Institution in 1962. In a letter dated July 19, 1979, Smithsonian curator of aircraft Robert C. Mikesh thanked Shindle for his role in helping to identify the fuselage as that of Admiral Byrd's airplane. "This was certainly not a snap judgment on either of your gentleman's part, and we appreciate the thoroughness you both made in your inspections of the fuselage welds. A positive identification of this airframe has been a questionable detail with us for many years, and we are relieved to have this solved." (Courtesy Danny Shindle.)

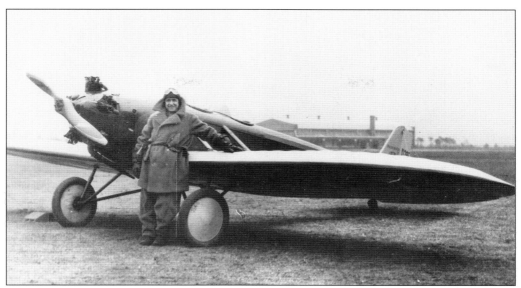

In 1928, the Fairchild plant in Farmingdale built the company's first open-cockpit airplane (above), a low-wing, two-place monoplane called the FT-1, which was powered by a 60-horsepower Simens-Halsked engine. When the FT-1 was redesigned, the plane was designated as Model 21. Capt. N. Berry of Interstate Air Lines stands beside the Model 21, which he flew to Chicago. Fairchild's FB-3 (below), the first all-metal pusher-type amphibian with folding wings, made its appearance in 1929. Powered by a 410-horsepower Pratt and Whitney Wasp B engine, the product of Fairchild's Metal Boat Division, formed in 1927, never went into production. The five-place flying boat was flown experimentally in 1929 and had a speed of 115 miles per hour from its 420-horsepower Wasp engine. (Courtesy WCHS.)

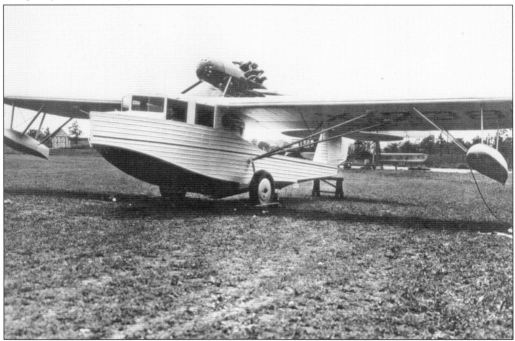

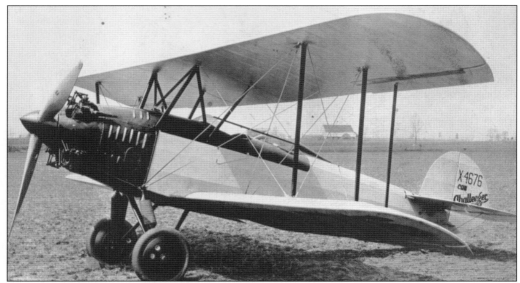

After Sherman Fairchild acquired controlling interest in Kreider-Reisner in 1929, the Challenger series was renamed as Fairchild KR models. The first of the three-seat biplanes to be built, the Challenger C-2, became KR-31, and the C-4 became the KR-34 (above). The first Fairchild-built plane to be used in combat was a modification of the KR-34. Built in Farmingdale in 1930, the light attack aircraft featured two fixed .30-caliber Browning machine guns, which fired forward through the propeller by means of synchronizers mounted on the Wright J-6-five engine. (Courtesy WCHS.)

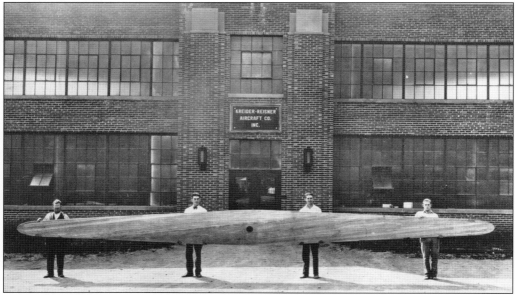

When the stock market crashed in 1929, the world of aviation faced possible disaster. With the slowdown prompted by the Depression, Kreider-Reisner employees had time to work on projects such as the autogiro blade. Holding the blade are, from left to right, J. G. Reeder, D. W. Shaw, C. S. Shaw, and Robert Gilbert in front of what became Fairchild Plant No. 1 on Pennsylvania Avenue at Park Avenue in Hagerstown. (Courtesy WMR.)

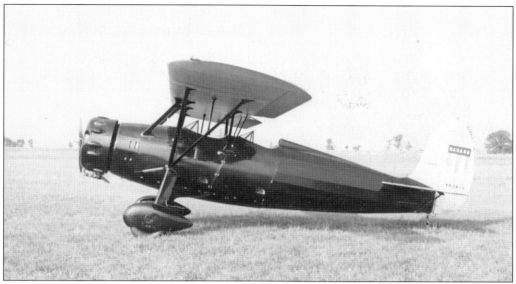

With the nation's financial stability in doubt, Fairchild introduced the 22, a two-seat, open cockpit, high-wing monoplane, in 1931. Much of the design work on the Fairchild 22 was done by Lewis Reisner. With a conventional landing gear on floats, the Fairchild 22 had a price tag of $2,675. The plane's experimental model was powered by the 80-horsepower Armstrong-Siddeley Genet engine, which was being built in the United States by the Fairchild Engine Company. (Courtesy WMR.)

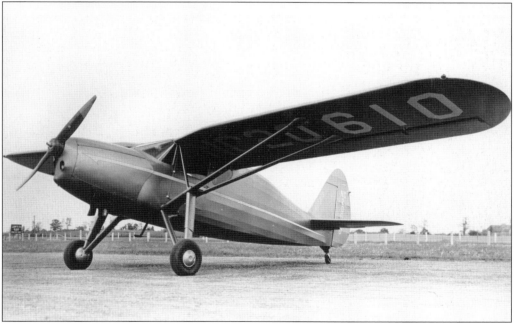

The F-24-R, one of the Model 24 series, was produced from 1932 until 1947. The Fairchild F-24 was believed to be the first plane in the country to fly with power developed from gasoline processed from coal. The historic flight in 1943 took place from Morgantown, West Virginia, to Washington, D.C. More than 500 F-24s were built in the 1930s. (Courtesy WCHS.)

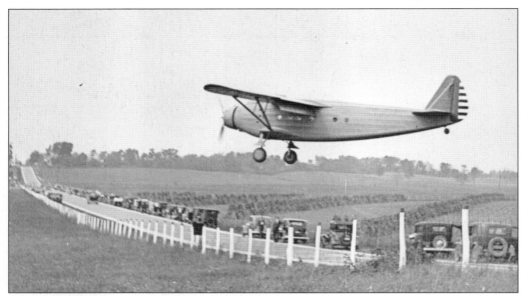

The XC-31, the first airplane designed specifically as an army cargo carrier, prepares for a landing at the Hagerstown Municipal Airport as it passes over spectators lined along Route 11 north of the city. Although Fairchild received no further orders from the U.S. Army Air Corps for the plane, some of the engineering used in the design of the XC-31 was employed in the production of Fairchild's C-82 Packet. (Courtesy Danny Shindle.)

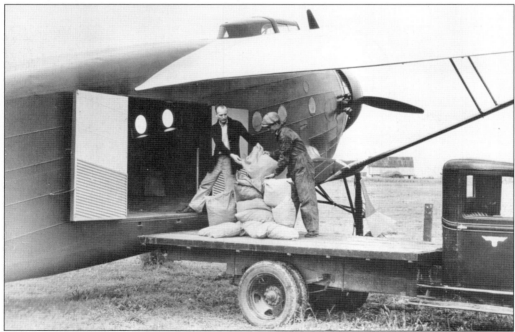

The XC-31, its floor at 4 feet above the ground, is being flat loaded. Being at the same height as the normal truck beds of the time and despite the XC-31's three-point attitude, the plane's cargo doors provided ease in loading. The XC-31, originally designated as the XC-941, was described as Fairchild's initial "Flying Boxcar." (Courtesy WMR.)

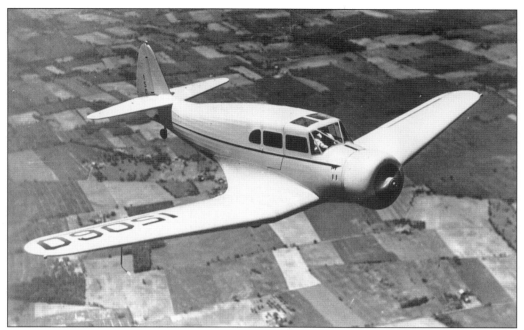

The initial flight of Fairchild's F-45, the "Sedan of the Air," was made on May 31, 1935. The F-45, built to carry five passengers, had fabric-covered wings and fuselage. A total of 16 F-45s were built from 1934 until 1938. Cruising speed was 173 miles per hour with a range of 1,250 miles. (Courtesy WCHS.)

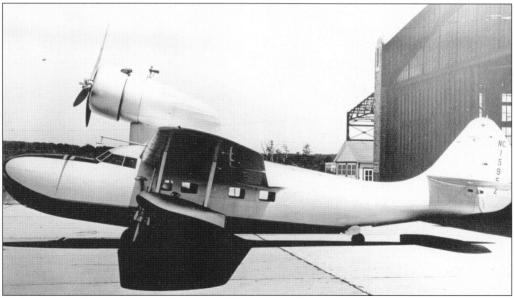

Fairchild's Model 91 was considered the largest and fastest single-engine amphibian of its time. The prototype of the single-engine monoplane made its initial flight on April 5, 1935. Designed by Fairchild's Al Gassner, one of the 91s was sold to explorer Richard Archibold. Archibold nicknamed his plane, which was said to resemble a duck, the "Kono" after the New Guinea word for duck. (Courtesy WCHS.)

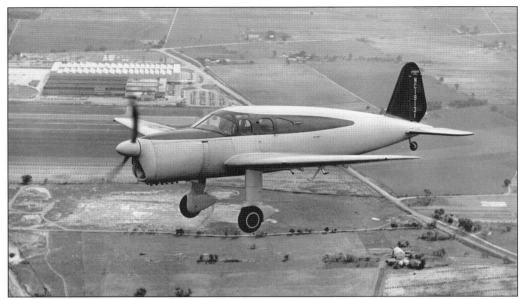

The F-46 was Fairchild's first plane to feature the duramold process, a method of molding wood and plastic under heat and pressure. The duramold process was designed to eliminate labor costs associated with the use of rivets in airframes. The process resulted in the formation of the Duramold Aircraft Corporation. The only Model 46 built is seen here flying over the Fairchild plant north of Hagerstown. (Courtesy WMR.)

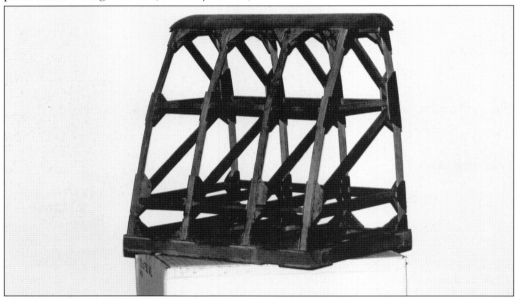

The PT-19 was an example of a Fairchild-manufactured airplane that used all-wood wings covered with laminated plywood for strength and aerodynamic efficiency. William H. McLean, a 41-year Fairchild employee, worked on building the wooden ribs for the wings and center sections of PT-19s at Plant No. 5 on East Wilson Boulevard in Hagerstown prior to World War II. The wing section above is housed at the Boonesborough Museum of History operated by Doug Bast. (Courtesy Doug Bast.)

Two

"COMMUNITY" EFFORT SPAWNS GROWTH

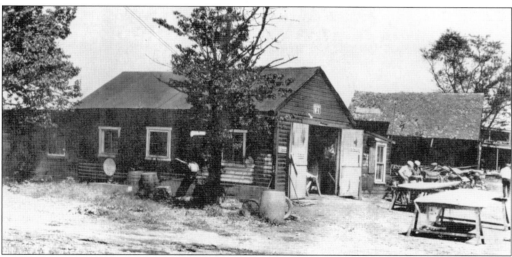

In the Little Green Shed, Kreider-Reisner Aircraft Company workers covered and doped wings, tails, and fuselages of aircraft. Measuring 16 feet by 30 feet, the wooden structure was a combination of two buildings joined together. When the weather cooperated, employees worked outside the collection of buildings along Pennsylvania Avenue in Hagerstown where the company's popular Challenger was manufactured. In the late 1920s, Kreider-Reisner purchased 60 acres of farmland along U.S. 11 north of Hagerstown and built a hangar. Planes would be towed from their Hagerstown location to the new airstrip, where the wings were attached, and the planes were test flown. During the winter of 2005–2006, the Little Green Shed was moved inside what had been Fairchild's Plant No. 1 on Pennsylvania Avenue. Eventually, the structure will be one of the Hagerstown Aviation Museum's exhibits. (Courtesy *Maryland Cracker Barrel*.)

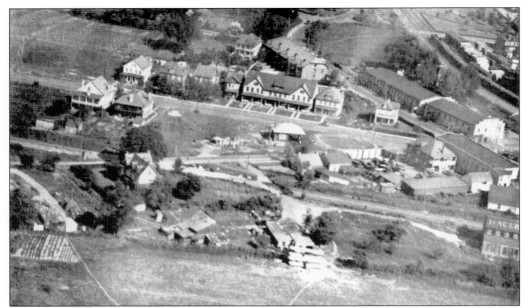

In the rear of the 800 block of Pennsylvania Avenue was Kreider-Reisner's airstrip, as seen in 1926. The airstrip was 600 feet long and bounded by high-voltage electrical lines at the northern approach and Angle's quarry to the south. Two biplanes can be seen in the foreground between the Little Green Shed and the airstrip. (Courtesy *Maryland Cracker Barrel*.)

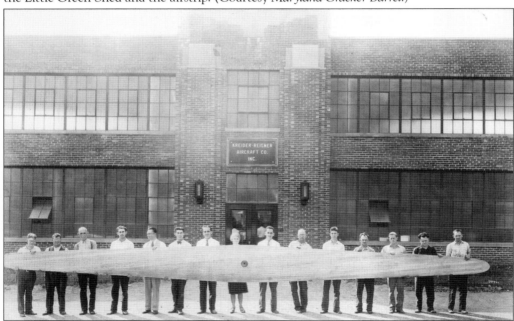

In 1929, the entire Kreider-Reisner office staff and plant workers hold an autogiro rotor blade in front of the company's new plant on Park Lane just off Pennsylvania Avenue. Pictured are, from left to right, ? Conrad, Jerise Reeder, Jacob Reisner, Bud Shaw, ? McCullum, Dan Shaw, Henry Reisner, Fay Brown, Lewis Reisner, Charley South, Don Revell, Ira Pike, unidentified, Carl Ahalt, and Merle Shindle. (Courtesy Danny Shindle.)

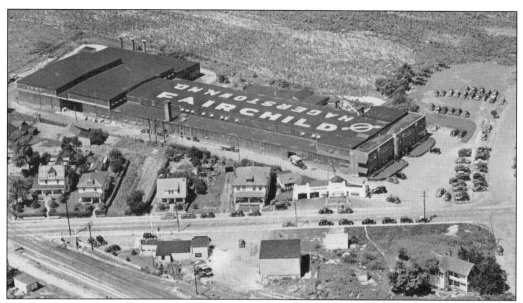

To accommodate its rapidly expanding aircraft production, Kreider-Reisner purchased 17 acres of land just north of the Little Green Shed and built a 32,000-square-foot factory in 1929. Known as Plant No. 1, the facility was used by Fairchild from 1929 until 1963. (Courtesy WMR.)

On October 28, 1936, workers with the Works Progress Administration, Project 3049, excavate the western portion of the east-west runway at the Hagerstown Municipal Airport, which was purchased by the City of Hagerstown from Kreider-Reisner in 1934. (Courtesy Edythe Rickard.)

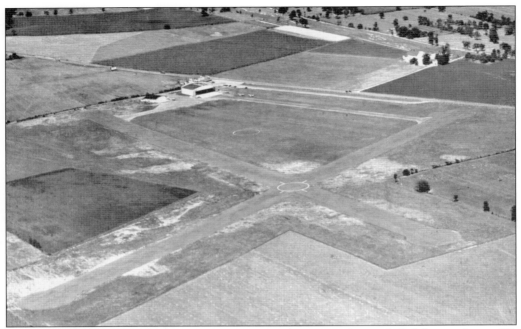

In 1935, Hagerstown launched a major expansion at the airport that included the purchase of 21 additional acres. Seventy percent of the $220,000 project was funded by the federal government. In addition to two paved runways, the expansion also included a large brick hangar with an attached office and waiting room. Hagerstown mayor W. Lee Elgin was on the committee for the dedication of the Hagerstown Municipal Airport, which was held on June 19, 1938. (Courtesy WMR.)

When Fairchild Aircraft's PT-19 won a U.S. Army Air Corps competition over 17 other airplanes in 1939, it became apparent that the army contract for 270 planes necessitated a larger facility. The result was Plant No. 2, which was completed in 1941 near the Hagerstown Municipal Airport north of Hagerstown. In the meantime, in order to meet production schedules, the "Hagerstown System" was employed. Ninety percent of Hagerstown's industrial capacity, 27 separate businesses, was called upon to help in the manufacturing of the PT-19. (Courtesy WMR.)

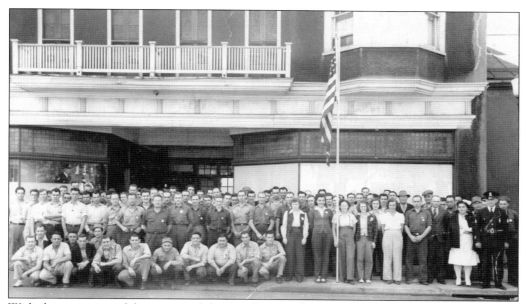

With the exception of the nurse and the guard pictured at right, Plant No. 14 on East Baltimore Street in Hagerstown was home for welders, who worked on the PT-19 in the early 1940s. The flag was bought by contributions from employees at Plant No. 14, now Laber's Office Furniture at 125 East Baltimore Street. Foltz Manufacturing Company of Hagerstown, another Fairchild subcontractor, donated the flagpole. (Courtesy Danny Shindle.)

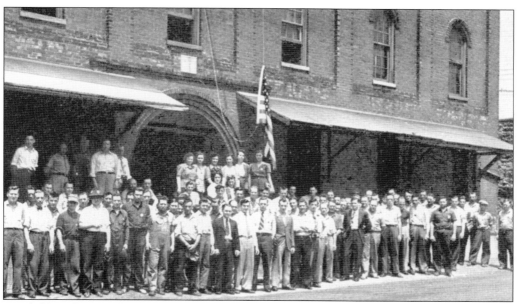

Fairchild workers at Plant No. 10 contributed nickels and dimes toward the purchase of a flag at their facility on North Prospect Street, now the home of the Hagerstown Rescue Mission. The flagpole was made and donated by the Hagerstown Lumber Company, now Maryland Millworks, Inc., on Frederick Street. (Courtesy *Pegasus*.)

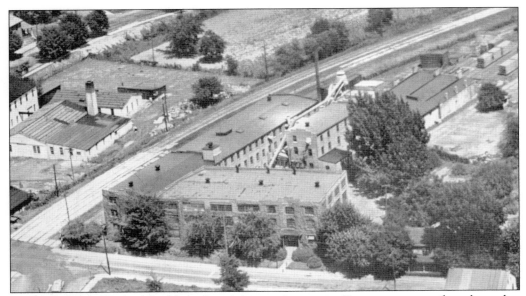

Brandt Cabinet Works (above) on Pennsylvania Avenue in Hagerstown contributed wooden fabrication and welding of aluminum sections for Fairchild and Glenn L. Martin planes. The firm was also awarded a navy contract to build mock-ups of the Grumman Wildcat fighter. Paul Carpegna and his sons Scott and Patrick own the company today. The Beachley Furniture Company (below) at 227 North Prospect Street converted its operation to manufacturing wooden parts and sections for the PT-19. Founded in 1887, the company is still owned by the Beachley family. Some of the other companies contributing to the war effort were Statton Furniture Manufacturing Company, Hagerstown Leather Company, Hess Auto Body Works, and the Foltz Manufacturing and Supply Company. Fairchild also employed the services of companies throughout the Tri-State area, including the Penn Elastic Company of Philadelphia, Pennsylvania, which had manufactured women's girdles and girdle-weaving equipment. In its new role, Penn Elastic manufactured primary trainer engine mounts. (Courtesy WMR.)

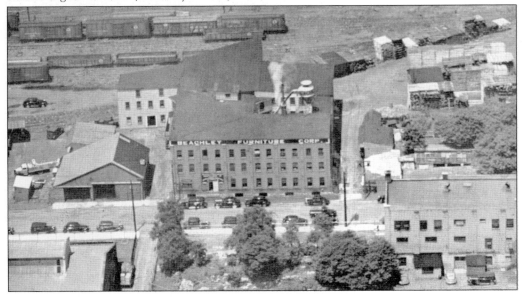

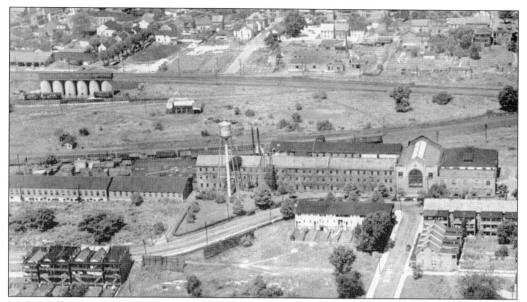

M. P. Moller Organ Works, the world's largest manufacturer of pipe organs, was one of the local industries that were part of the Hagerstown System. In its first year as a war-production subcontractor, Moller produced 3,400 wing panels and 2,000 center sections for the primary trainers assembled in Hagerstown. In 1941, Moller had 168 employees, and by 1943, there were 850 employees, 238 of them women. (Courtesy WMR.)

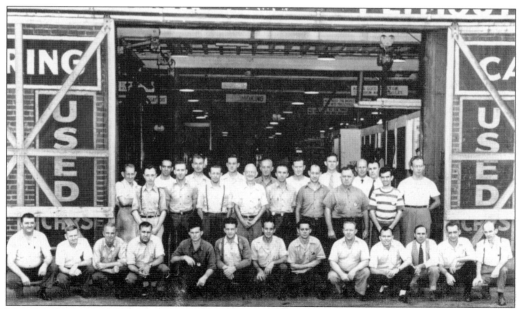

Maryland Motors, located next to the Hagerstown Post Office on West Franklin Street, was another business whose employees were part of the Hagerstown System and was referred to as Plant No. 13. In February 1946, Fairchild moved the operations from the Maryland Motors facility to Plant No. 2, north of Hagerstown. (Courtesy Gail Mongan.)

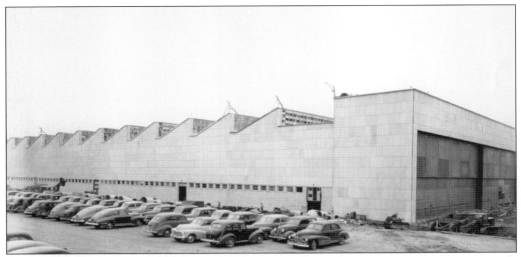

A new addition (above) of more than 200,000 square feet to Plant No. 2 went into service early in 1944. Equivalent to the height of a six-story building, the structure was used initially for the building of the C-82 cargo plane. The distance between columns in the plant in any direction was 20 percent greater than the wingspan of the C-82, which was 106 feet, 6 inches. Two 20-ton cranes (below), capable of traveling in any direction over the entire manufacturing floor space, were used in the building of the giant cargo plane. A three-rail track ran from the subassembly sections into the final assembly bay to facilitate movement of the aircraft. Large glass panels arranged in sawtooth fashion in the main portion of the plant provided natural no-glare light for workers. Doors at the final assembly end of the building measured 46 feet high and 125 feet wide. The first truss of the new building was put into position on December 7, 1943, the second anniversary of Pearl Harbor. (Courtesy WCHS.)

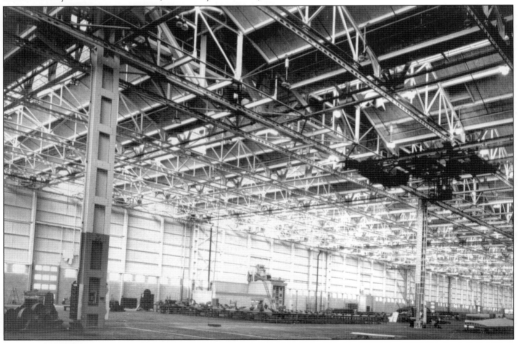

While work on the east addition is seen in the foreground, the hangar, Plant No. 6, is seen in the background. Completed in October 1943, the wooden Quonset-type building housed Flight Test Operations. The contractor for the hangar was Norman S. Earley and Son of Hagerstown. (Courtesy WCHS.)

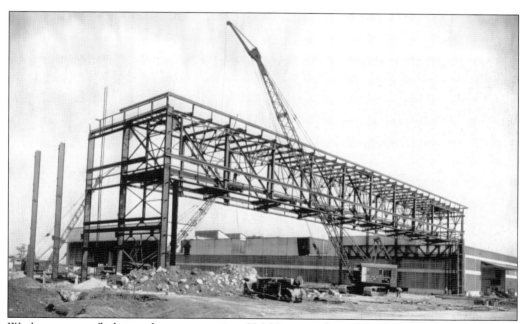

Work on a new flight-test hangar covering 60,000 square feet of floor space adjacent to Plant No. 2 began in the spring of 1945 and was completed in April 1947. Known as Plant No. 7, the structure was built originally for flight-test operations on the C-82. Two sets of overhead sectional canopy doors, each measuring 250 feet wide and 36 feet high, opened on either side of the hangar. (Courtesy WCHS.)

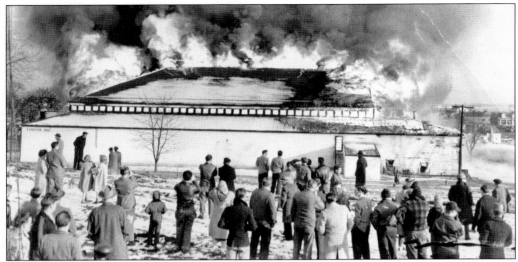

Once the site of one of the nation's largest poultry shows, the Exhibition Hall at the Hagerstown Fairgrounds was utilized by Fairchild in its role as a subcontractor for the Glenn L. Martin Company in Baltimore. Hagerstown-area resident Preston Buck went to work in the Exhibition Hall in August 1941 after undergoing "defense training" at Hagerstown High School. On Monday, March 26, 1945, the Exhibition Hall, known as Plant No. 8, was officially vacated by Fairchild, and in December 1950, the structure was consumed by fire. (Courtesy Vernon Davis.)

During Fairchild's peak production period in World War II, the company employed, either directly or indirectly, 80 percent of Hagerstown's working population. On May 2, 1943, Fairchild figures revealed that there were 8,117 men and women employed, up from 141 workers listed in 1939. On November 13, 1951, Fairchild's employment office was moved to Plant No. 9 at 805 Pennsylvania Avenue in Hagerstown. Plant No. 9, which at one time was used by Kreider-Reisner in the manufacturing of the Challenger biplane, also housed Fairchild's Industrial Relations Department. (Courtesy Bob Fabris.)

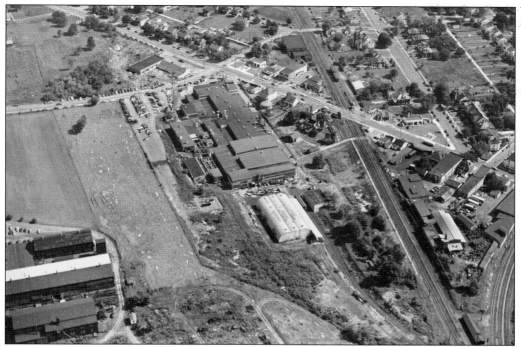

In the foreground of the photograph above is Fairchild Plant No. 8, located behind Plant No. 1 on Park Lane in Hagerstown. The metal Quonset-style building, which was completed in 1947, had a storage capacity of 12,500 square feet with a 26-foot ceiling and was used to store sheet, bar, tube, and rolled metals and castings. (Courtesy Doug Bast.)

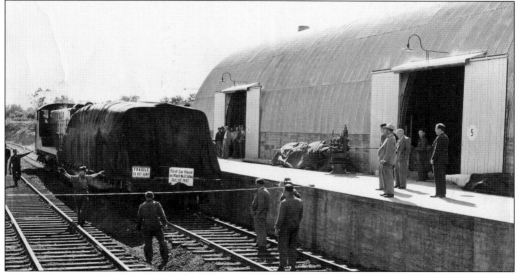

Representatives of Fairchild and the Western Maryland Railway gathered at Plant No. 8 in 1947 to welcome the first freight car into the new siding built by the Western Maryland. The siding accommodated 18 standard railroad cars. Standing between the tracks is Fairchild employee Clarence Ebersole. Standing on the dock is Frank Greenwalt (with the hat), Fairchild maintenance staff engineer. (Courtesy Gary Carter.)

Fairchild's Jet Engine Test Facility was located at the Hagerstown Municipal Airport behind the tower and the T-hangars. Built in the early 1950s, the plant was managed by Charles Bauserman. Here jet engines were tested for conformity. The test facility had an outside test pad and two indoor test stands with a control room for each. The photograph below shows the control room and instrumentation for one of the test cells. Various engines, including the General Electric J-85, the Pratt and Whitney J-60, and the Fairchild J-44 and J-83, were tested at the facility, as was a steam rocket, which was tested in August 1962 shortly before the facility closed. (Courtesy William "Bill" Wright.)

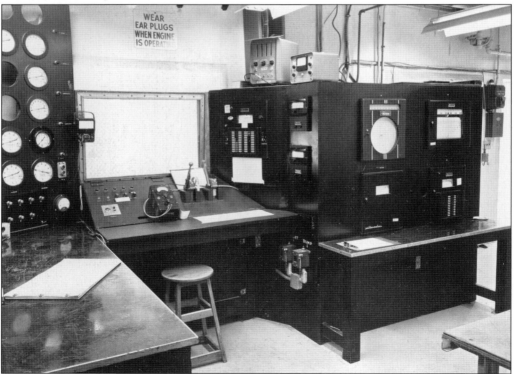

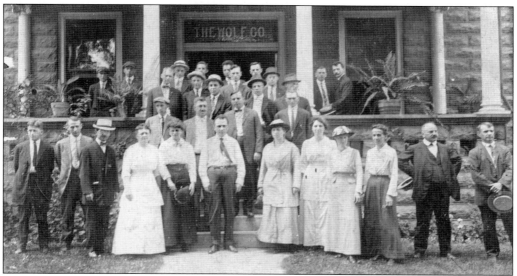

In 1953, Fairchild leased two buildings in Chambersburg, Pennsylvania, to be used primarily as storage plants for its Hagerstown operations. Established in 1879, the Wolf Company provided 170,000 square feet of floor space that were under the supervision of Fairchild's Materials Department. The 1915 photograph above was taken in front of the Wolf Company, which became Plant No. 30. The Wolf Company was known worldwide for the manufacture of flour, corn, cereal, and feed mill machinery. The photograph below shows an addition being constructed for the Chambersburg Ice and Cold Storage Company on Kennedy Street in 1929. In November 1953, Fairchild leased the five-story south building of the facility, which became known as Fairchild Plant No. 31. The two Chambersburg plants provided more than a quarter of a million square feet of storage space for material used in the production of the C-119. (Courtesy Franklin County Historical Society.)

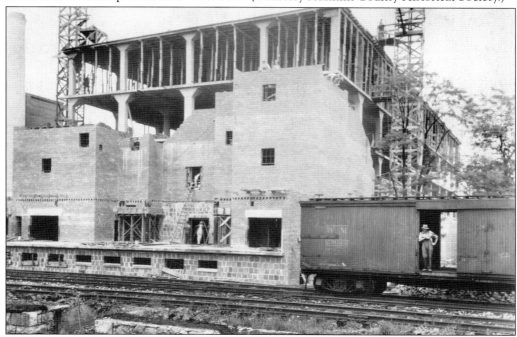

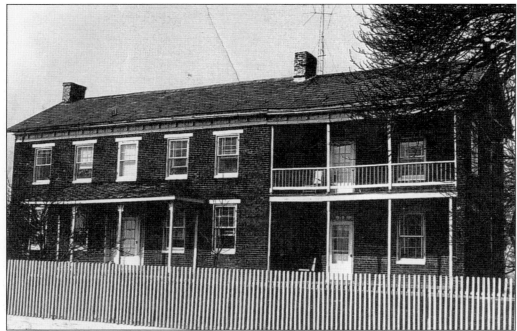

In 1955, Robert Brumbaugh and his wife sold their 97.8-acre farm along Route 11 north of Hagerstown to Fairchild for $50,000. The property, which was purchased for future development by the company, was located north of the north-south runway at the Hagerstown Municipal Airport near the Airport Inn. Beulah Koons Behm, whose great-grandparents Beulah and John Nickolas Brumbaugh built the house and barn, was born in the house in 1920. Beulah Behm's grandfather John K. Brumbaugh and her mother, Elizabeth, were also born in the home. (Courtesy Beulah Koons Behm.)

In 1958, runways at the Fairchild plant near Route 11 were upgraded. Originally paved in the late 1930s, the runways were approximately 2,500 long. The 1958 project required that a portion of Route 11 be moved eastward. One of the workers, Sam Hall III, is seen in this photograph, second from the left. (Courtesy Gary Carter.)

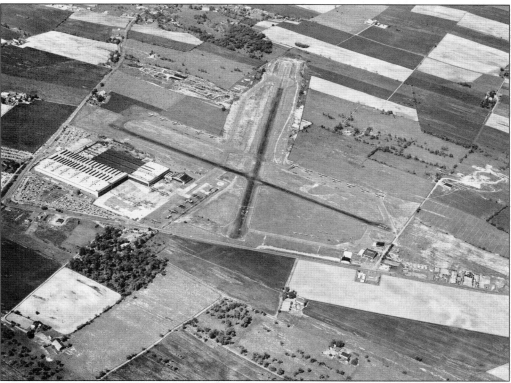

The expansion program of 1952 guaranteed that Fairchild's Hagerstown plant was the largest facility in the Fairchild Hiller complex. The six camelback trusses used in the east building were fabricated in three sections on the ground, with the three sections weighing a total of 84 tons. (Courtesy Doug Bast.)

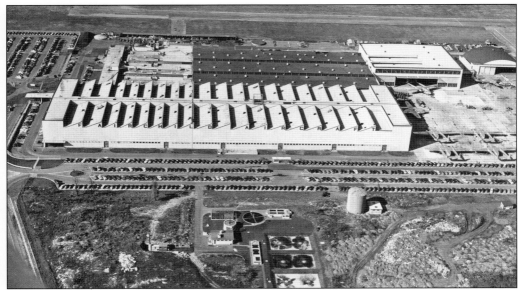

Fairchild's main plant off Showalter Road is seen above before the start of construction on a major expansion in the early 1950s. In June 1951, the U.S. Air Force granted approval for the expansion needed to increase the production of the C-119 Flying Boxcar. The U.S. Air Force, the largest single user of the C-119, provided $7 million for the program, while Fairchild provided more than $2 million. Completed by the end of 1952, the expansion was carried out without interruption in production schedules for the C-119. A 200-by-765-foot production bay (foreground below) adjacent to Plant No. 3 featured "bowstring trusses," with their top chords extending above the roof level. This architectural feature allowed the entire 200-foot width of the production area to be free of vertical columns. The new bay increased the production area by 165,000 square feet, bringing the total floor area to approximately 500,000 square feet. Numerous C-119s could be seen around the Fairchild plant. (Above courtesy WCHS; below courtesy Doug Bast.)

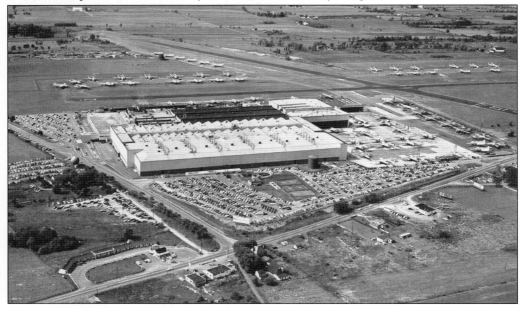

Three

GLOBAL UNREST PROPELS FUTURE

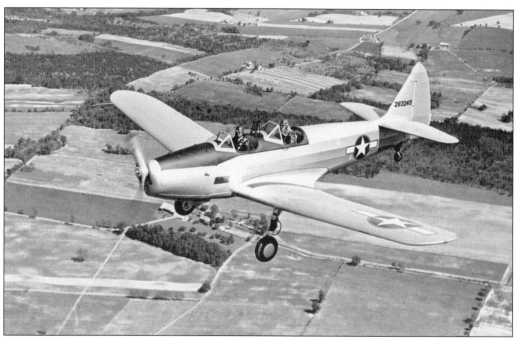

"Men don't review all their sins, or even a part of them, just before they die. I know because I died twice in one afternoon," stated a student pilot after his initial flight in a PT-19 trainer. Designed by chief engineer Armand J. Thieblot, the PT-19 won a U.S. Army Air Corps competition at Wright Field in Dayton, Ohio, in the summer of 1939. Consequently, Fairchild was awarded a contract to build 270 PT-19s. In a booklet entitled *A Collection of Fairchild Aircraft*, it was noted that "more World War II pilots received their cadet primary training in this plane than in any other types combined." (Courtesy Robert Kefauver.)

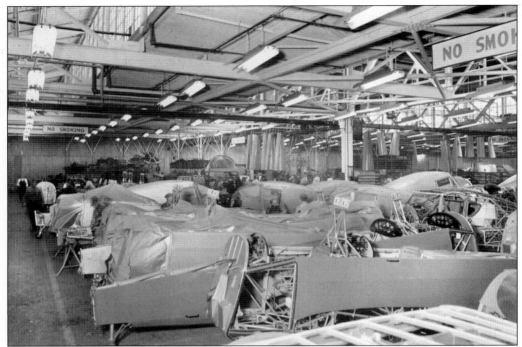

The PT-19, which became identified with the city of Hagerstown, was a favorite for schools and colleges across the country as they subscribed to enough war bonds and stamps to purchase more than 1,000 PT-19s by May 1944 in the "Buy-A-Plane" campaign, which was sponsored by the Treasury Department. During peak production in World War II, Fairchild manufactured 178 PT-19s each month and more than 5,000 during the global conflict. The paint on the PT-19s pictured above dries while the planes await further assembly. (Courtesy WCHS.)

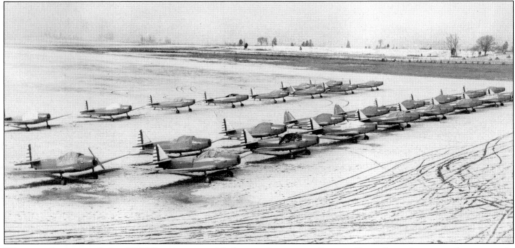

The production of the PT-19 was so rapid that a shortage of propellers forced many planes to sit idly near the Fairchild plant in late 1940. Countless aviation cadets, some of whom had never been in an airplane before, earned their "wings" in the PT-19. At Texas's Victory Field, an army primary school, and its many satellite fields, cadets flew more than 13 million miles with just a single fatality. (Courtesy Danny Shindle.)

Initially powered by a 165-horsepower Ranger engine, the PT-19 was modified with a 200-horsepower Ranger engine and designated as the PT-19 Cornell. As a young cadet, former Fairchild crew chief Dick McNeal commented, "I sure got to love the PT-19. They sure were a swell little ship." The PT-19 gave former Fairchild production test pilot Fred Kuhn his initial exposure to flying while in Primary Flight Training at Mustang Field near El Reno, Oklahoma. (Courtesy Dave Verdier.)

FAIRCHILD PT19 "CORNELL"
RANGER 6 ENGINE

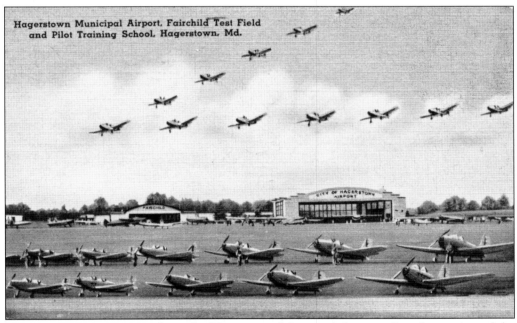

Hagerstown Municipal Airport, Fairchild Test Field and Pilot Training School, Hagerstown, Md.

Here PT-19s are swarming above the Hagerstown Municipal Airport. One description of the Fairchild aircraft noted that the PT-19s were "buzzing about the airfields of Texas and Oklahoma like bees about a honeysuckle vine." One instructor noted, "Our job is to teach these boys to fly, and our job has been made easier by the fact that the PT-19 is probably the safest trainer in the air. We aim to teach them never to make the same mistake twice. Cadets make mistakes in the PTs so they won't make them when the cards are down in combat." (Courtesy Janet Dayhoff.)

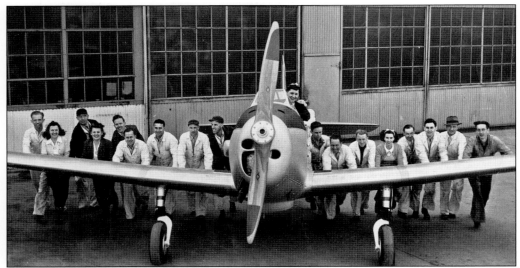

The 5,000th PT-19 is being pushed out of Plant No. 4's doors in April 1944 with Department 125 employee Jennie Suranno in the cockpit. Early in 1944, it was announced that the War Department had terminated its contract for the PT-19. Ironically, the last PT-19 produced at Fairchild was "purchased" by students from Hagerstown's South Potomac Junior High School through the Treasury Department's "Buy-A-Plane" campaign. (Courtesy Paul and Jennie Suranno Nally.)

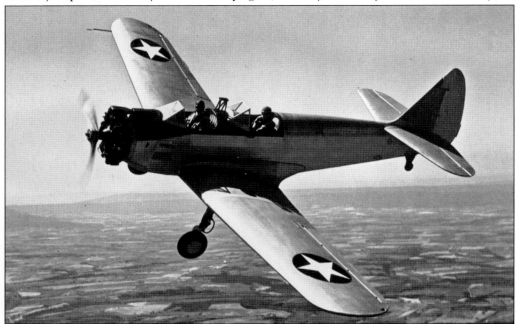

Fairchild's Hagerstown plant built only two PT-23 production prototypes, but several other companies built many of the Fairchild-designed planes, which became popular in the Southwest as a trainer. One air cadet in Louisiana commented on his experiences in the PTs. "Tell your company workers that although the air speed indicators are redlined at 190, I pulled my plane out of a dive from 11,000 feet down to 4,000 with an indicated air speed of over 200! She didn't even creak!" (Courtesy WCHS.)

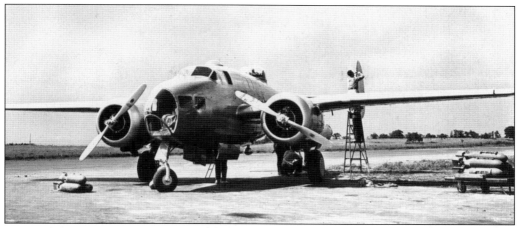

In March 1941, Fairchild was awarded a contract from the U.S. Army Air Corps to build an advanced trainer, designated the XAT-13 (above). Powered by a pair of 600-horsepower Pratt and Whitney radial engines, the plane made its maiden Hagerstown flight on July 19, 1942. Changes to the AT-13 eventually resulted in the production of the AT-21 aerial gunnery trainer (below). A shortage of space at Fairchild's Hagerstown plant resulted in utilizing a facility in Burlington, North Carolina, for the express purpose of manufacturing the AT-21. With a top speed of 210 miles per hour and a range of over 700 miles, the aircraft was equipped with a pair of .30-caliber machine guns mounted in the power-operated turret, which rotated a full 360 degrees. The nose gun was also .30-caliber. A bombsight was included as well as bomb bay doors, which could be used if needed. Because of the molded plywood used in the construction of the AT-21, skeptics were dubious of the plane's ability to withstand the punishment that metal planes endured. However, late in 1943, the "Gunner" successfully passed rigid U.S. Army Air Force static tests at Wright Field in Dayton. (Courtesy WCHS.)

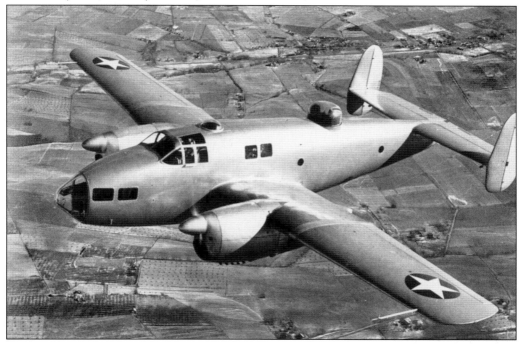

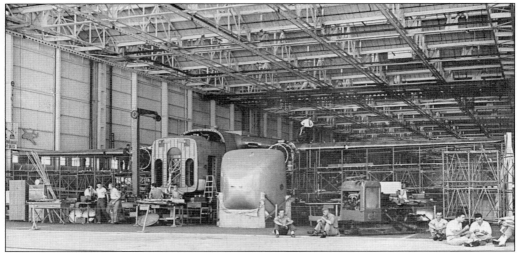

When the front and rear walls were removed from the experimental area of Fairchild's Plant No. 2B in May 1944, many workers were amazed at the enormity of the fuselage of the C-82 as they viewed the cargo plane for the first time. During World War II, the army realized the need for a better transport plane and as a result, in November 1941, the army designated the new aircraft the C-82 Packet and ordered Fairchild to redo drawings from an all-wood airplane to an all-metal plane. The C-82 entered operational service in May 1945, and by September 1948, Fairchild had produced 223 C-82s, the first Allied end-loading aircraft assembled in quantity. In the summer of 1944, noted race pilot Benny Howard came to Hagerstown to conduct taxi tests on the new airplane. Numerous taxi runs were made at various speeds by the "parachuteless" crew. Suddenly, to the amazement of most of the crew, the XC-82 became airborne. When asked how the plane became airborne, Howard replied, "It just felt like flying, so I flew it!" (Courtesy Danny Shindle.)

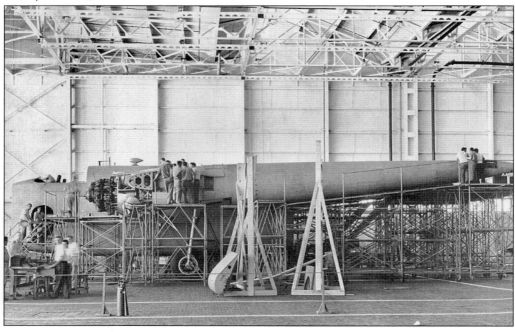

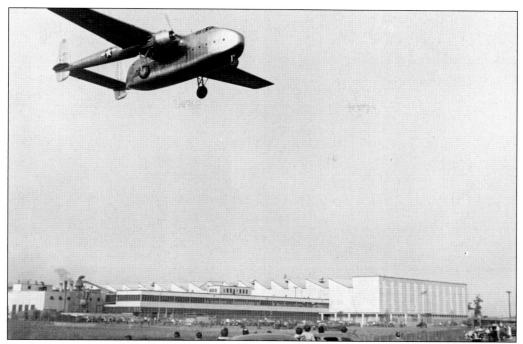

At 6:18 p.m. on Sunday, September 10, 1944, with its silver fuselage and twin booms gleaming in the late afternoon sun, the C-82 took off on the north-south runway near Fairchild Plant No. 2 on its initial flight-test. The twin-engine, high-wing monoplane circled above a throng of onlookers for nearly 15 minutes with Benny Howard at the controls and Dick Henson serving as copilot. Accompanying them were experimental flight mechanic Jimmy Hines and Dan Weller from Flight Test Engineering. (Photograph by Lyle Mitchell; courtesy Robert Kefauver.)

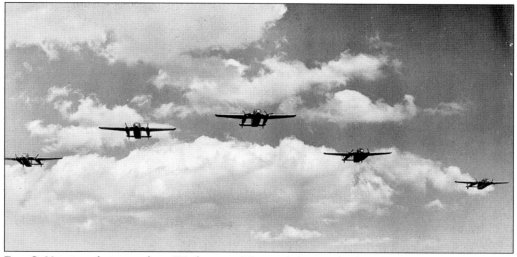

Five C-82s wing their way from Washington National Airport back to Hagerstown in May 1946 after taking part in a U.S. Army Air Force demonstration before an estimated crowd of 100,000 onlookers. Earlier in May, while doing routine testing at Wright Field, the XC-82 was flown with its rear cargo doors removed to explore the feasibility of using parachutes to drop jeeps and other heavy equipment while in flight. (Courtesy Meredith Darlington.)

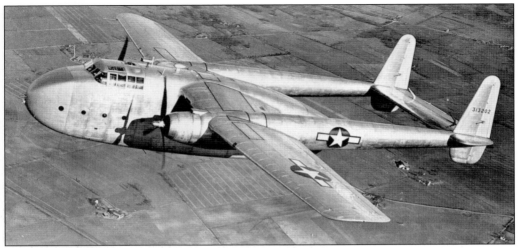

While the German surrender of Berlin in May 1945 signaled the cessation of war in Europe, the conclusion of the war in that theater brought an expansion to the production of Fairchild's C-82. Fairchild general manager R. S. Boutelle announced, "We do not lay down our tools when the Germans quit fighting. On the contrary, it will be the signal for added effort on our part. The C-82 Cargo has a date in the Pacific, and it is our task to get it there." (Courtesy Meredith Darlington.)

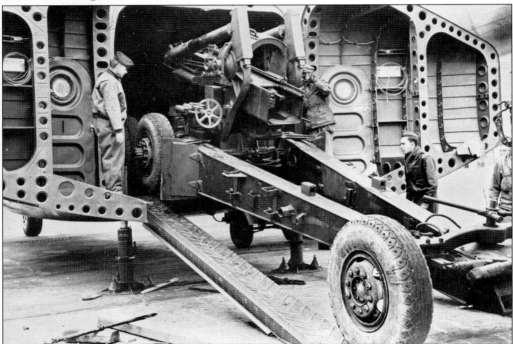

An advertisement that appeared in the January 1945 edition of Fairchild's *Pegasus* magazine commented on the versatility of the C-82. "While today it can carry the weapons of war, tomorrow, with but minor modification, it can transport the goods of peacetime commerce." The cargo compartment of the aircraft carried 93 percent of the capacity of a railroad boxcar. (Courtesy Bob Fabris.)

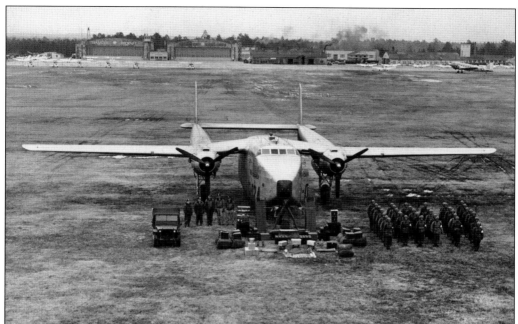

After reviewing airborne strength at Fort Bragg, North Carolina, in October 1949, Pres. Harry S. Truman complimented the famed 82nd Airborne Division. Part of the demonstration witnessed by the president was the jump of 1,000 men from Fairchild C-82s. The plane's rear doors allowed the chutist to dive into the slipstream at a near zero-degree angle, where turbulence is at a low point. The distance from the rear of the fuselage to the tail section was sufficient enough to eliminate the danger of the jumper snagging the tailplane. Another advantage of employing the C-82 in dropping paratroopers was the centerline point of departure, which eliminated the need for the pilot to slow the door-side propeller more than the other one. With both engines throttled uniformly, better control of the plane could be maintained by the pilot at near stalling speeds. (Above courtesy WMR; right courtesy Linda Kreilick.)

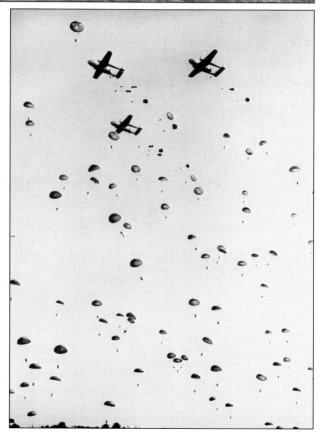

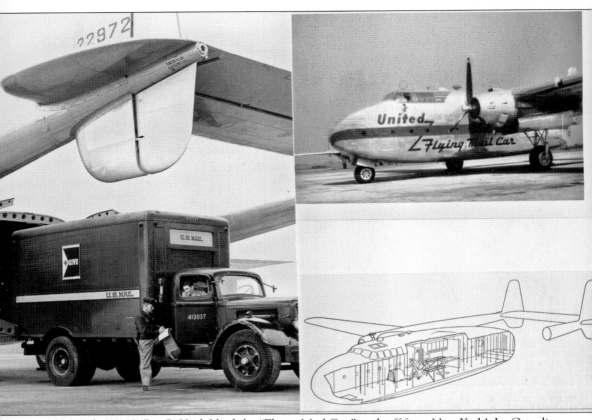

On October 1, 1947, a C-82, dubbed the "Flying Mail Car," took off from New York's La Guardia Field en route to San Francisco, and the flight marked the use of 5¢ airmail service in the United States. With the aid of the Experimental Shop, crews under Plant Operations head J. Earl Steinhauer fabricated and installed equipment necessary to convert the C-82 into a post office on wings. Federal restrictions later forced the project to be abandoned. The Fairchild cargo plane was used in a variety of other ways in the postwar era, including the Berlin Airlift in 1948–1949. When snows threatened to wipe out vast herds of cattle in the western part of the country in 1949, the C-82 was called to the rescue in Operation Haylift. An estimated 4,244,000 pounds of hay were dropped in a mission to save 300,000 head of cattle. One of the unique uses of the Fairchild aircraft came during the Berlin Airlift in missions known as Operation Little Vittles, a project in which candy was dropped to German youngsters. On one such flight in 1949, Fairchild's field service representative in Germany, Gene Tibbs, recalled dropping "about 1,000 pounds of candy bars. These are wrapped two bars together and tied to a handkerchief parachute by 14-inch string risers. In case you're interested, we did hit our target." (Courtesy Meredith Darlington, Dick McNeal, and FAD.)

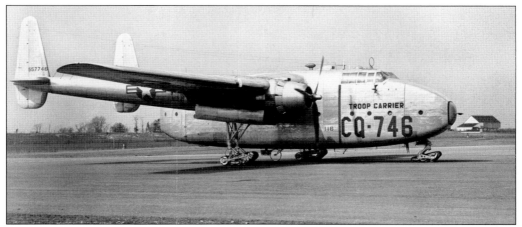

The C-82 Packet was the first cargo transport to go into production with a thermal wing-heating system. In December 1946, Fairchild made its first official announcement regarding a traction-type landing gear for the C-82, giving it increased aerial mobility. The plane had been selected to test the track-type landing gear because of its ability to land and takeoff on short, unimproved fields. (Courtesy WMR.)

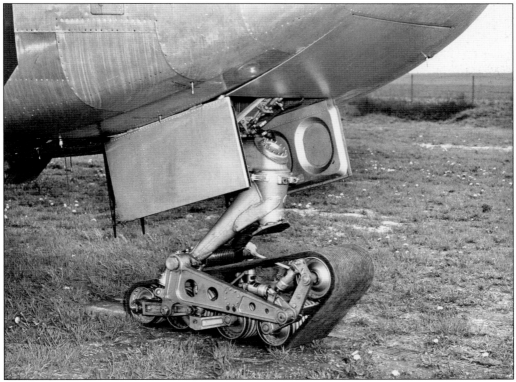

Installation of the "flying runway" began at Fairchild's Hagerstown facility in 1947. The track-type gear exceeded the C-82's wheel installation by 275 pounds for the nose and 400 pounds for each main gear. On March 17, 1948, the track-equipped C-82 was taxied out for ground testing of the gear, and three weeks later, Fairchild chief test pilot Dick Henson conducted the first flight tests on the plane. (Courtesy WMR.)

Fairchild's navy primary trainer, the XNQ-1, made its initial test flight in the fall of 1946 with Dick Henson at the controls. With a maximum speed of 170 miles per hour, the XNQ-1 was the first primary trainer equipped with a controllable pitch propeller. The airplane, with a wingspan of 41 feet, 5 inches, was powered by a Lycoming nine-cylinder engine rated at 320 horsepower. (Courtesy Dick McNeal.)

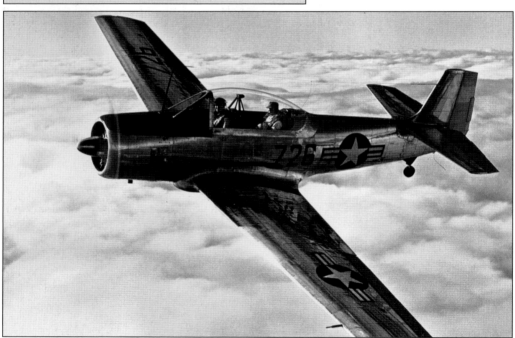

In 1949, the U.S. Air Force placed an order with Fairchild for 100 T-31 trainer planes at a cost exceeding $8 million. The T-31, which allowed a student and instructor to be seated beneath a one-piece sliding "bubble" canopy, was the U.S. Air Force's version of the navy XNQ trainer. The maximum speed for the trainer was 166 miles per hour at sea level with a maximum range of 900 miles at 110 miles per hour. (Courtesy WCHS.)

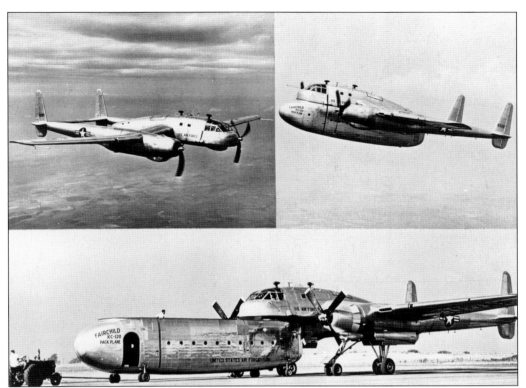

In June 1950, the XC-120 rolled out of the Fairchild plant north of Hagerstown. Designed by Armand Thieblot, the military cargo plane was built under a U.S. Air Force experimental contract. The plane resembled the C-119 with the major difference being that the XC-120 was able to fly without the fuselage. Unfortunately for Fairchild, the aircraft was never ordered into production. (Courtesy Merle Barnhart.)

Fairchild's Dick McNeal, of the Flight Test Department, mounts a 15-foot collapsible ladder that was used to enter and exit the XC-120 when the pod was detached. The portable ladder weighed approximately 29 pounds, light enough for handling by one individual, and was stored beneath the navigator's table when the plane was in flight. (Courtesy Dave Verdier.)

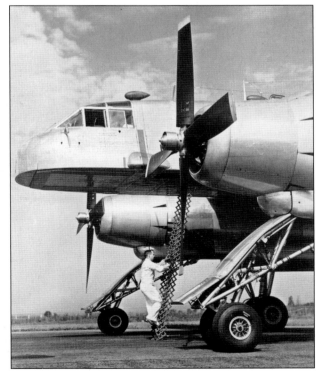

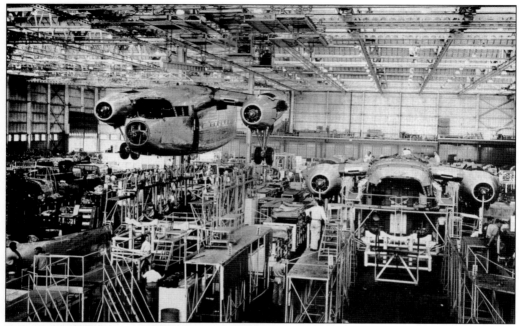

Because of the U.S. Air Force's desire for larger engines than those on the C-82, a new Packet was born—the C-119. In December 1947, it made its first test flight. In April 1948, the first production model of the new troop and cargo aircraft made a public appearance on the concrete ramp at the end of Fairchild's final assembly line at the Hagerstown plant. In October 1955, the final C-119 built—number 1,112— rolled out of the Fairchild plant. (Courtesy Doug Bast.)

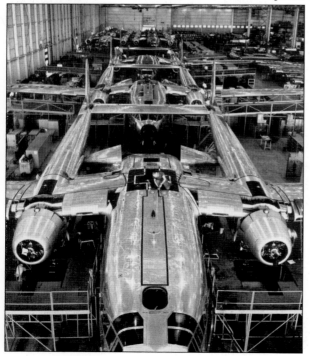

C-119s are pictured on the assembly line in January 1954. One of the improvements on the plane was moving the flight deck from high atop the fuselage to a new location that improved crew visibility. This move increased the cargo hold size to nearly 3,100 cubic feet. With the increased capacity, it took only 59 "Flying Boxcars" to drop an entire regimental combat team as opposed to 147 transports to complete the same assignment in World War II. (Courtesy Bob Fabris.)

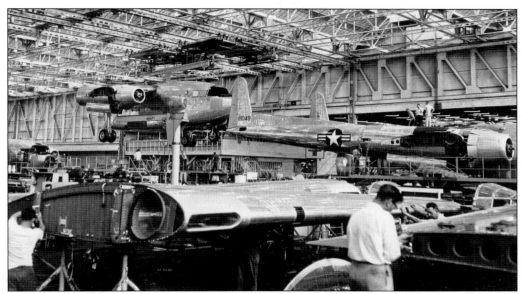

More than one million separate parts were incorporated into the manufacture of a single C-119. Included in this number were 568,177 rivets, which were purchased in quantities as high as 10,000 pounds. Fairchild used a network of more than 700 suppliers from across the country to obtain parts for the cargo plane. The role of purchasing, as well as the other four divisions comprising the Materials Department, was vital to Fairchild meeting its production schedules. (Courtesy Bob Fabris.)

Fairchild chief engineer Walt Tydon (left with microphone) explains the operation of the "beavertail door" mock-up to a crowd of military personnel in April 1952. The primary purpose of the visit was to inspect the new C-119H, which differed from the C-82 and the C-119 in appearance in most respects save the boxcar-like fuselage. The 148-foot-span "big wing Flying Boxcar" was designed specifically to meet army combat cargo requirements. (Courtesy Bob Fabris.)

One of the disadvantages of the trademark clamshell doors used on the C-82s and C-119s built until 1955 was that they could not be operated in flight and had to be removed before takeoff. Crews dropping cargo fought the wind and cold, and the gaping hole in the rear of the plane decreased cruise performance. To offset these problems, Fairchild engineers designed a multi-section door, which was hinged at the top and bottom edges of the fuselage and featured a flight-operable, self-contained ramp. The doors, pictured above and retrofitted on a C-119 below, formed a streamlined, wedge-shaped extension when closed, which gave rise to the term "beavertail." Many C-119s were retrofitted with the beavertail doors, which were operated hydraulically and controlled by the pilot, copilot, or at a crew station in the cargo compartment. One of the drawbacks of the new door, however, was that paratroopers jumping from the side exit doors were often injured as they were bounced along the "beavertail." (Courtesy Doug Bast.)

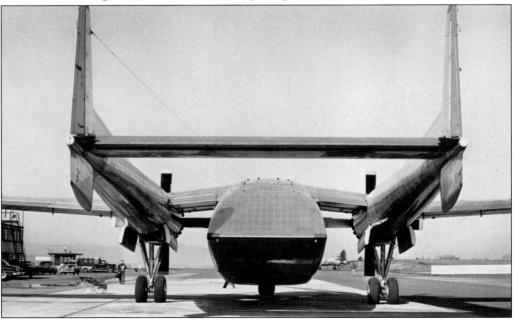

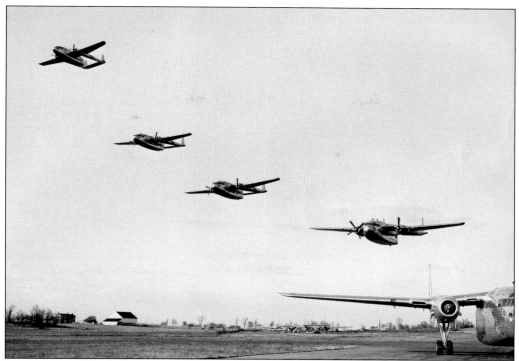

C-119s scheduled for delivery to the Tactical Air Command at Smyrna Air Force Base are seen flying over Fairchild's Hagerstown plant. The initial delivery of the C-119 was made to the Tactical Air Command late in the fall of 1949. Capable of carrying 42 fully equipped paratroopers, the plane could also transport twenty 500-pound bundles of supplies. (Courtesy Dave Verdier.)

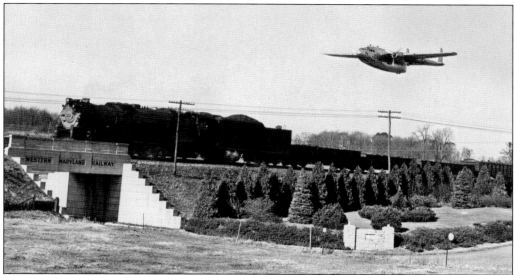

The prototype C-119 zeroes in on a Western Maryland Railway train at the Waynecastle underpass between Waynesboro and Greencastle, Pennsylvania. Popularly known as the "Dollar Nineteen," the C-119 was succeeded by the C-130 Hercules, but U.S. allies continued to use the C-119 for many years. (Courtesy Linda Kreilick.)

In 1949, Fairchild developed a new and simpler ballast system for use in flight-testing of the C-119. A C-119 drops 1,440 gallons of water ballast instead of heavy shot bags formerly used in experimental C-119s. By using the water ballast, Fairchild flight-test engineers could duplicate any weight and balance loads that the plane would be required to carry. (Courtesy WCHS.)

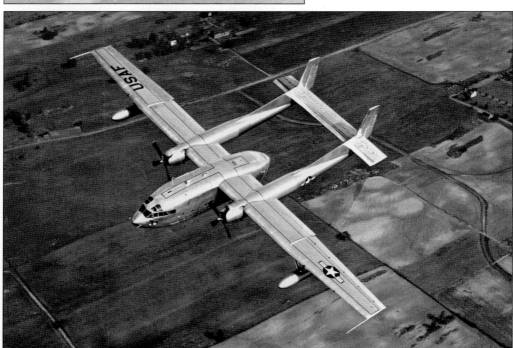

At 6:35 a.m. on May 27, 1952, the sleek C-119H, nicknamed the Skyvan, lifted off the ground from Fairchild's Hagerstown plant on its maiden test flight. Chief test pilot Dick Henson was at the controls with E. R. "Dutch" Gelvin serving as copilot. Dan Weller was the flight-test engineer on that flight, which lasted almost 2.5 hours. The other crewmen were Roy Carter (crew chief) and W. A. Grove (electrician). (Courtesy Bob Fabris.)

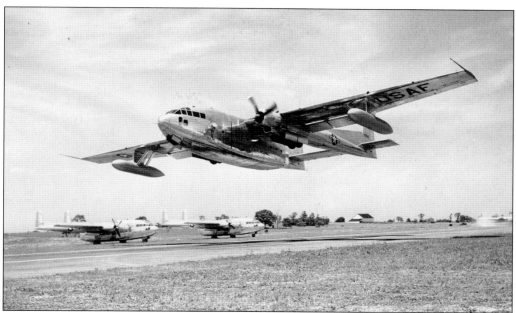

Two of the features that made the C-119H so unique were its slender 148-foot wingspan giving it 25 percent greater lift capability and a pair of external underwing tanks, each containing 1,700 gallons of fuel and measuring 4.5 feet in diameter. By incorporating external fuel tanks into the design of the plane, all internal plumbing, valves, and access doors were eliminated, thus saving 835 pounds in weight. Additionally, the location of the fuel tanks reduced their exposure to gunfire. Equipped with longer tail booms and larger vertical and horizontal tail surfaces, the plane could clear a 50-foot obstacle at just 2,280 feet while lifting a normal takeoff weight of 86,000 pounds, which included a payload of nearly 28,000 pounds. Military officials believed that the aircraft's low stall and landing speeds, along with its large payload, made it ideal for operation in advance combat zones. Despite the promise of the C-119H, the U.S. Air Force had its sights set on Lockheed's C-130 Hercules. Thus, the new design never went into production. (Courtesy Bob Fabris.)

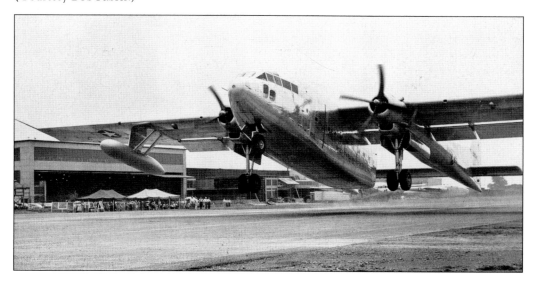

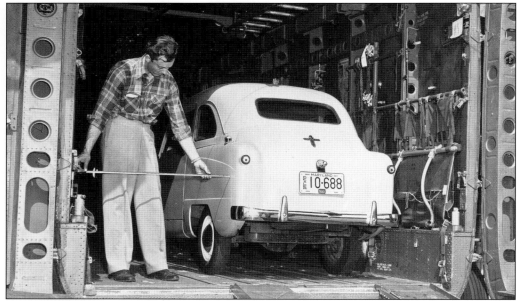

One of the major differences between the C-82 (above) and the C-119 (below) was the width of the latter, which had a 14-inch-wider fuselage and center section. During the Christmas season in 1952, a C-82 of the 60th Troop Carrier Wing and a C-119 of the 317th Wing teamed up to deliver 17,000 pounds of Christmas packages to needy youngsters in Berlin, Germany. The gifts were loaded at Rhein-Main Air Force Base by members of the German Junior Red Cross. The Flying Boxcars' value during the Korean airlift and to UN combat forces in the early 1950s was immense. C-119s of the Far East Air Force hauled 164,000 tons of supplies and air dropped 18,000 tons. A total of 30,500 troops jumped from the C-119 in combat and training missions, and 5,500 battle casualties were evacuated aboard the Fairchild plane. (Courtesy WMR.)

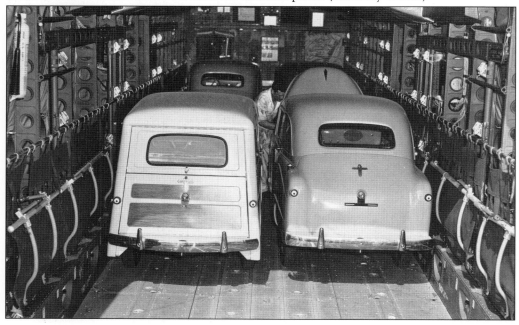

In January 1954, more than 130 C-119 Flying Boxcars of the 18th Air Force were assembled at Fort Bragg in North Carolina during phase two of Exercise Sky Drop One. In the photograph at right, nine tons of equipment is being dropped from the cargo holds of the C-119s flying without their clamshell doors. The white parachute seen above the plane on the left is the drop chute. Below, the paratainer doors of a C-119 are pictured. A dramatic airdrop on December 7, 1950, saved the lives of the 1st U.S. Marine Division and elements of the 7th U.S. Army Division, who were encircled by Chinese communists in North Korea's Chosin Reservoir area. As the trapped troops looked skyward, their gaze saw eight C-119s, each dropping a 4,500-pound section of an 18-ton M-2 tread way bridge. Two G-5 parachutes, 48 feet in diameter, were attached to each bridge section. That night, American forces escaped to safety over the first bridge ever to be dropped by parachute in the history of warfare. (Right courtesy Doug Bast; below courtesy Bob Fabris.)

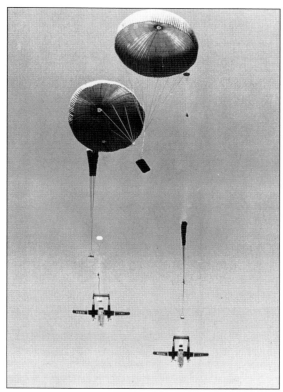

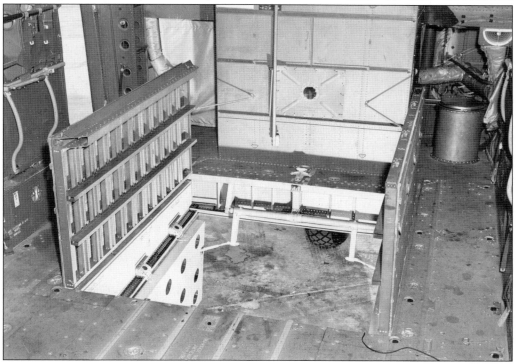

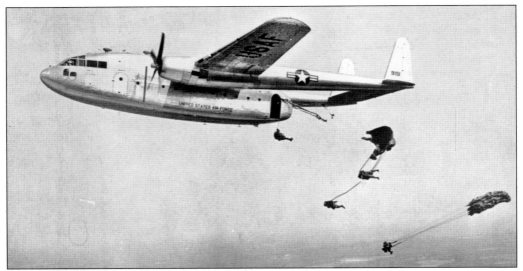

Above, a C-119A drops paratroopers from its rear jump doors. Among the numerous names given to the C-119 were the "Flying Boxcar," the "Packet," "workhorse of the airlift," and "cargo cow," a name given by *Life* photographer Howard Sochurek. In the November 6, 1950, issue of *Life*, Sochurek, while covering the mass drop of paratroopers into North Korea, described the C-119s lined up on an airstrip as "herds of cargo cows." One of the unusual uses of the C-119 was that of a wedding chapel at Seymour-Johnson Air Force Base in North Carolina in 1954. The cargo compartment of a C-119 (below) is pictured with a full complement of seats. By incorporating an I-beam monorail delivery system, the C-119 could drop 10,000 pounds of supplies and equipment in a single operation in addition to its normal complement of 42 fully equipped paratroopers. (Above courtesy Doug Bast; below courtesy Bob Fabris.)

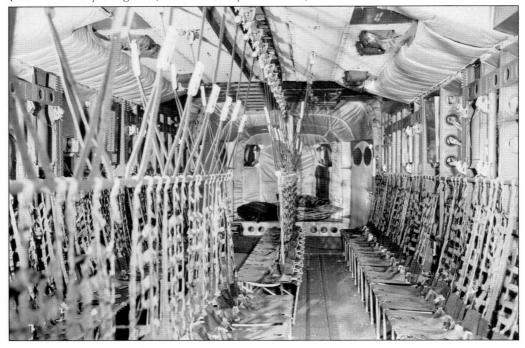

Troops from the 82nd Airborne of the 80th Anti-Aircraft Battalion stand ready for inspection along with a 40-mm gun and prime mover in front of a C-119. The 1,000th Flying Boxcar was delivered to the U.S. Air Force on Thursday, December 16, 1954. Fairchild advertised that 1,000 C-119s could carry 60,000 troops with full field equipment; 3,000 jeeps and their crews; 1,000 tactical helicopters; or 1,000 155-mm howitzers and prime movers. (Courtesy Dave Verdier.)

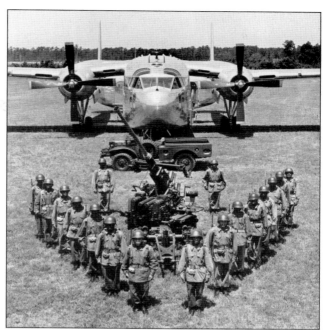

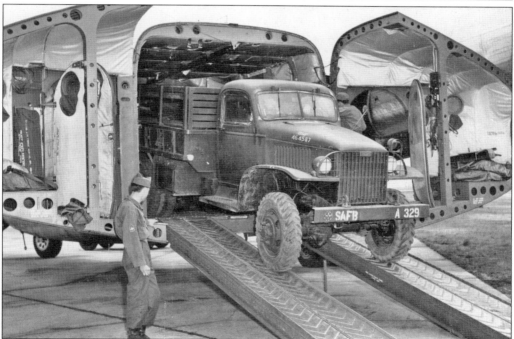

A crew from the 11th Airborne Division loads a 6-by-6-foot prime mover into a C-119 in preparation for a military operation (or war game) known as Exercise Swarmer at Fort Bragg, North Carolina, in 1950. A total of 50 C-119s from Sewart Air Force Base in Tennessee participated in the war games conducted by the U.S. Army and U.S. Air Force. As a result of the C-119s' performance during Exercise Swarmer, Maj. Gen. James Gavin, wartime commander of the 82nd Airborne Division, called for an increase in the supply of Fairchild C-119s. (Courtesy Dave Verdier.)

Fairchild held a license to sell and build the Fokker S-14 (above), manufactured initially by the Fokker Aircraft Company of the Netherlands. Demonstration flights on the S-14 were temporarily halted in 1955 after Fokker chief test pilot Lt. Col. Gerben Sonderman was killed while putting the jet-powered trainer through its paces at Fairchild's main plant. Fairchild employee JoAnn Chaney Swope remembers watching the plane disappear. "It circled the plant, and I saw the plane go down. Then I saw the smoke rise." Former Fairchild employee Bill Rinn, who was manager of Henson Flying Service at the time of the crash, serviced the plane before Sonderman's fateful flight. Rinn recalls that Sonderman had offered "to put on an air show" for Fairchild officials, who tried to talk him out of it. Findings from the Civil Aeronautics Board indicated that the accident occurred "either because the pilot miscalculated the altitude required to recover from the aerobatic maneuver being performed, or that the pilot was physically incapacitated due to heart disease." (Above courtesy Robert B. McKinley; below courtesy Russ Howard.)

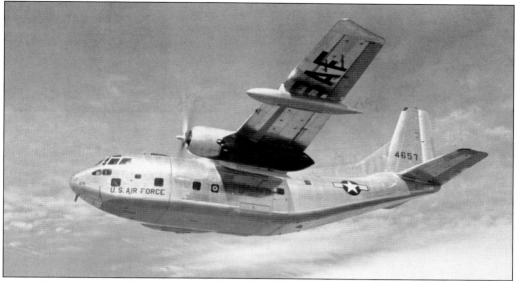

A C-123 piloted by Fred Kuhn is seen flying over the Hagerstown area on its initial flight in 1954. Fairchild's C-123s were required to have two hours of flight testing prior to being turned over to the U.S. Air Force. When the C-123 Avitruc was delivered in the summer of 1954, it was the first production assault transport ever placed in service with the U.S. Air Force. (Courtesy Fred Kuhn.)

A fleet of C-123s at the Fairchild plant fails to interfere with the serenity of the rural area north of Hagerstown in 1957. It was in 1953 that Fairchild won a contract to build the transport plane for the U.S. Air Force. One of the primary advantages of the C-123 was its capability to land and takeoff in rough terrain. The plane's tactical mission was to transport combat and engineering equipment for airborne assault troops. (Courtesy *Pegasus*.)

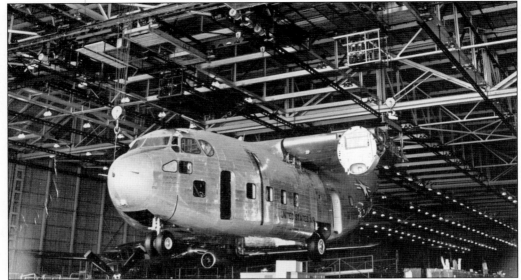

The first Fairchild C-123 Avitruc (above) gets hoisted over the existing C-119 assembly line. Though somewhat overshadowed by Lockheed's C-130 Hercules, the C-123 proved its ruggedness across the world. In bringing thousands of tons of construction and electronic material to radar sites beyond the Arctic Circle in 1956, the planes landed on runways containing rocks as large as oranges and lemons. Built originally for service in the Korean War, the C-123s (below) were later successfully used in the Vietnam conflict as the foremost cargo and troop carrier in the jungle operations during the mid-1960s. Fairchild production efficiency in a three-year period in the mid-1950s resulted in total refunds of $20 million to the government, as Fairchild came in under the contract amounts specified by the government. (Above courtesy Bob Fabris; below courtesy Doug Bast.)

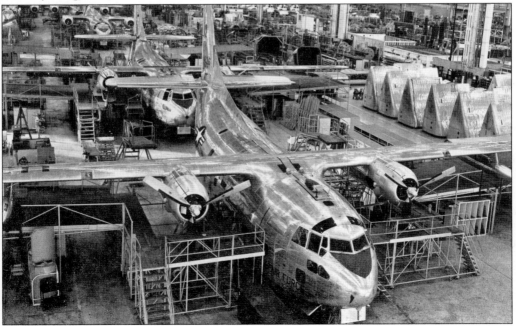

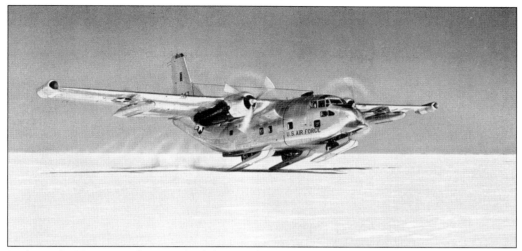

In the mid-1950s, tests of a new wheel ski gear developed by Fairchild were conducted in Bimidji, Minnesota. Complete with J-44 jet engines on each wing tip and the ski gear design, the C-123J was delivered to the U.S. Air Force on February 5, 1958. Initially, 10 C-123Js were assigned to the Strategic Air Command to conduct training and support missions in the area of the Greenland Ice Cap. (Courtesy WMR.)

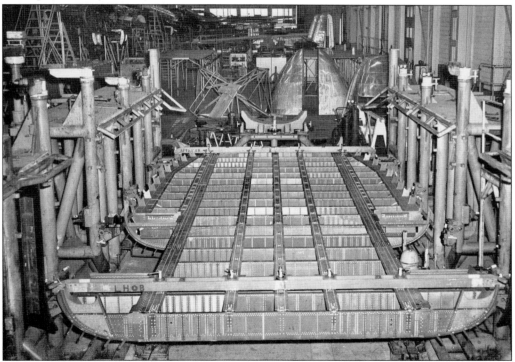

The inner edges of the wheel cutouts in the main floor assembly of the C-123 were 110 inches apart. The cargo compartment of the plane was rigged to hold approximately 60 combat infantrymen. In a U.S. Air Force static demonstration at Pope Air Force Base in North Carolina in 1955, the largest piece of equipment to be loaded into the C-123 was an M-49 truck-mounted crane shovel weighing 15,780 pounds. (Courtesy Bob Fabris.)

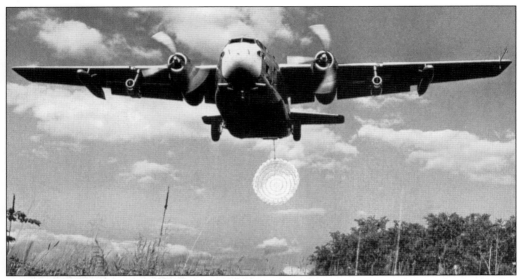

A C-123H is about to land near Hagerstown with Russ Howard at the controls. Copilot Fred Kuhn has just released the drag chute, which was used to improve short field landings. In addition to installing the drag chute system on the plane designated the XC-123H, Fairchild also put CJ610 engines on the aircraft, which left the Fairchild plant one week ahead of schedule in 1962. The newly designated YC-123H was damaged beyond repair in a landing in August 1963. (Courtesy Russ Howard.)

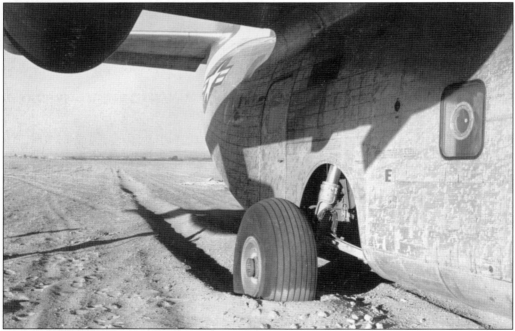

The wide-tread landing gear of the C-123 is embedded in the sand at Yuma, Arizona. Fairchild's design of the new gear, which gave the pilot more control of the plane and permitted shorter takeoff and landing distances, was successfully tested by the Air Proving Ground Command in 1957 at Pope Air Force Base in North Carolina. (Courtesy Russ Howard.)

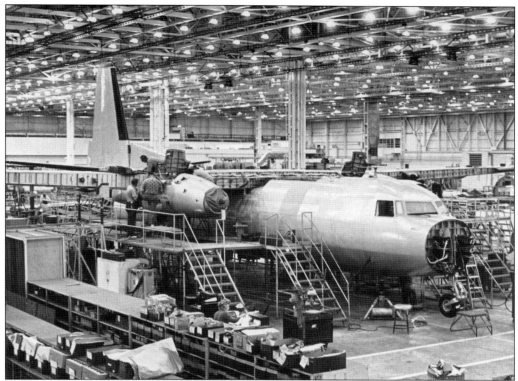

On June 22, 1958, Fairchild celebrated the delivery of its initial F-27. West Coast Airlines was the recipient of the plane and became the first scheduled airline to place a turbo-powered aircraft into service in the United States. An F-27 is on the assembly line in 1962, one of the more than 200 F-27s and FH-227s built at the Hagerstown facility from 1958 to 1968. (Courtesy *Maryland Cracker Barrel*.)

Eloise Shaffer (right), longtime Fairchild employee, is pictured in a brochure advertising the F-27. Charles Wandel, Fairchild assistant comptroller, sits opposite Shaffer, while a fellow employee sits behind her. The F-27 was the first turbine-powered aircraft certified to fly in the United States. A pair of Rolls Royce engines enabled the plane to cruise at 300 miles per hour. (Courtesy Eloise Shaffer.)

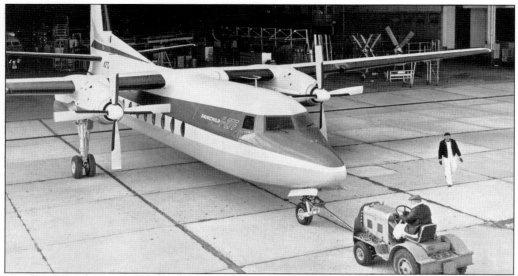

The 201st F-27 (above) manufactured by Fairchild is rolled off the assembly line in 1963. Below, Fairchild chief executive officer Ed Uhl, Bonanza Air Lines president Edmund Converse, and Hearst newspaper national editor Frank Coniff talk with stewardess Kay Krum of Bonanza Airlines during ceremonies recognizing the delivery of the 201st F-27. When a 6-foot fuselage section was added to the F-27 beginning in 1966, the plane took on the designation FH-227. The addition increased capacity to more than 50 passengers. An agreement between Fairchild and Fokker gave Fairchild manufacturing and sales rights for the F-27 in North and South America with the exception of Brazil. The prototype F-27 was first flown at Schipoll Airport in Amsterdam, Holland, on November 24, 1955. Fairchild flight-test pilot Dick Henson was at the controls for a 45-minute test hop during one of the 10 test flights. (Courtesy Robert Kefauver.)

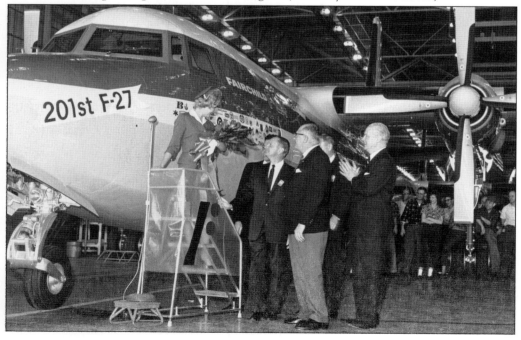

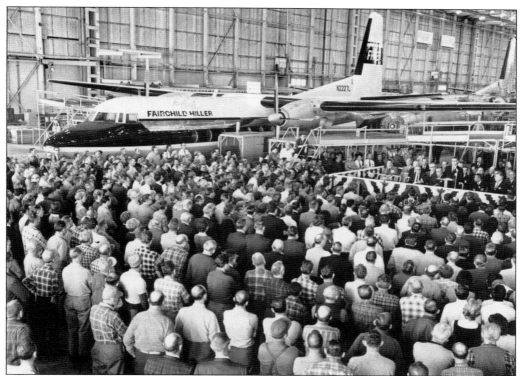

On February 2, 1966, the first FH-227 (above), a new twin-prop jet transport, rolled off the assembly line at Fairchild's Hagerstown plant. Below, Fairchild test pilot Russ Howard lifts off during a test flight of the FH-227 in March 1966. It was announced in February 1965 that Mohawk Airlines, the largest of the nation's 13 regional carriers at the time, had purchased 18 of the FH-227s. The $24-million order represented the largest commercial aircraft sale in Fairchild history and was the largest single new equipment purchase ever made by a regional airline. When Northeast Airlines ordered six FH-227s in December 1965, Northeast board chairman George B. Storer Jr. stated, "We selected the FH-227 after a careful study of many types. It is the only aircraft developed specifically to serve shorter routes and smaller airports." (Above courtesy *Maryland Cracker Barrel*; below courtesy Russ Howard.)

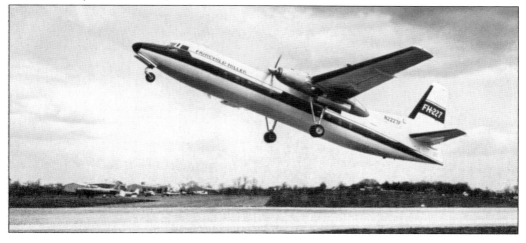

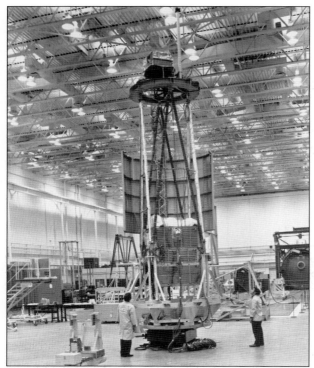

In 1971, Fairchild's Germantown facility began work on the Applications Technology Satellite (ATS) program for the National Aeronautics and Space Administration (left). In addition to expanding communications horizons, the program served as a platform for multiple scientific experiments. One of the immediate uses stemming from the ATS program was aiding educational television in remote areas of Alaska and the Rocky Mountains, where terrestrial television coverage was not practical. Experiments were also conducted to transfer weather and geophysical data collected by satellites near earth's orbit. Below, a satellite is being loaded for shipment. (Courtesy Charles Good.)

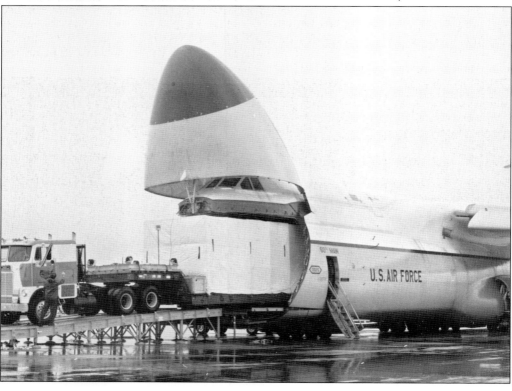

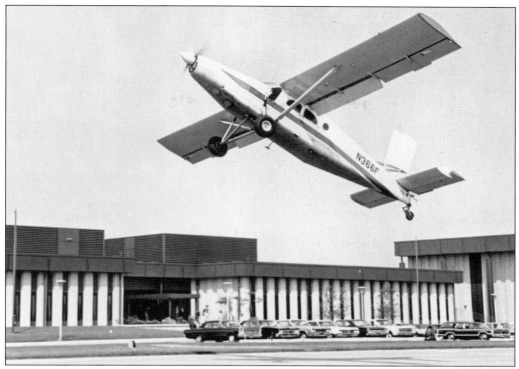

A Fairchild Porter piloted by Al Maye takes off from the landing strip at the Sherman Fairchild Technology Center in Germantown, Maryland. Fairchild chief executive officer Ed Uhl routinely flew from his Hagerstown home to Germantown in a Porter, a versatile short take-off and landing airplane (STOL). With a cruise speed of 166 miles per hour, the Porter could takeoff in 300 feet or less and land in less than 150 feet. (Courtesy Eloise Shaffer.)

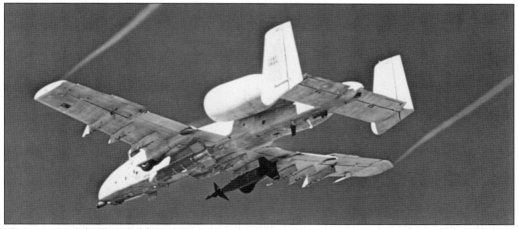

Flight tests of the Fairchild A-10A, designed to provide close support for friendly ground forces, began in the summer of 1972. Under a contract with the Department of Defense, Fairchild built more than 700 A-10s beginning in the 1970s. The final delivery of the Thunderbolt II, number 713, was made to the U.S. Air Force on March 20, 1984. The aircraft was officially named the Thunderbolt II during ceremonies in April 1978, when the 100th A-10A was delivered to the military. (Courtesy John Kreigh Jr.)

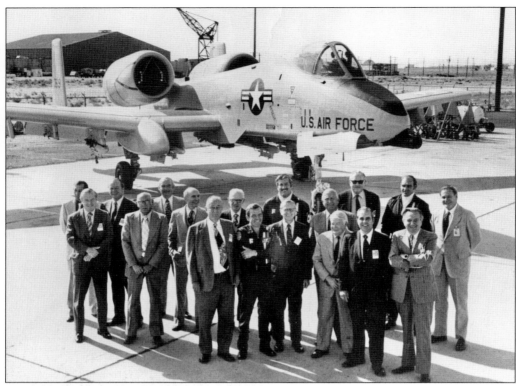

Fairchild officials stand in front of an A-10, affectionately known as the Warthog, at the Hagerstown plant. Fairchild chief executive officer Ed Uhl is standing in the front row, third from the left. Uhl said that the name Warthog was used by "the guys that were flying it!" Equipped with night vision imaging systems, the A-10 design protects pilots with titanium armor. The aircraft itself can survive direct hits from armor-piercing projectiles up to 23 millimeters. (Courtesy Eloise Shaffer.)

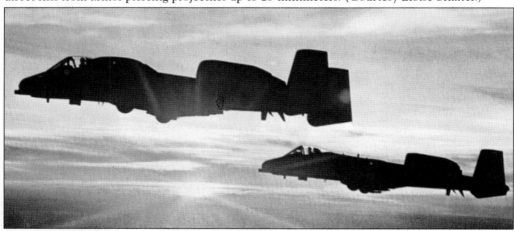

A-10s are equipped with General Electric 30-mm cannons, the largest Gatling-type gun ever installed in an airplane. With seven barrels, the gun is capable of firing up to 4,200 rounds per minute. The plane is also capable of firing both free-fall and precision-guided weapons, rockets, and Maverick missiles. One of the unique features of the A-10 is the drooped wing tips, which provided additional lifting capability at low speeds. (Courtesy John Kreigh Jr.)

Four

LEGACY ATTRIBUTED TO FAIRCRAFTERS

Born on April 7, 1896, Sherman Mills Fairchild devised the world's first between-the-lens shutter for aerial cameras and a technique for eliminating distortion in photographs, making accurate aerial mapping possible. Because his father, George W. Fairchild, was one of the founders and the first president of IBM, Fairchild, as a youngster, used a factory full of time clocks and adding machines as his playground. In 1920 at the age of 24, Fairchild founded the Fairchild Aerial Camera Corporation. In 1929, he bought controlling interest in Hagerstown's Kreider-Reisner Company. One of the nation's leading industrialists, Fairchild was honored by the Smithsonian Institution in 1970 for his 50 years in aviation. Fairchild, a bachelor, never earned a college degree, although he attended Harvard, the University of Arizona, and Columbia University. The Oneonta, New York, native died at Roosevelt Hospital in New York City on March 28, 1971, at the age of 74. (Courtesy Eloise Shaffer.)

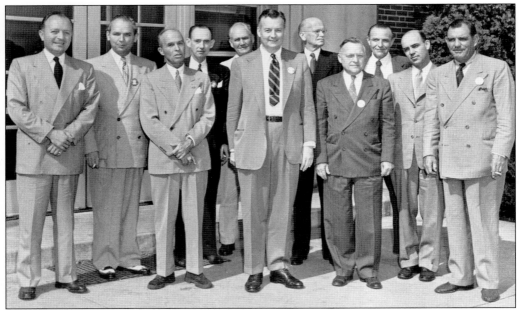

The board of directors of Fairchild Engine and Airplane Corporation is pictured here on September 1, 1949, in Farmingdale, Long Island, New York. Pictured are, from left to right, L. M. W. Bolton, William D. McIntyre, Grover Loening, Arthur F. Flood (vice president, treasurer, and controller), Earnshaw Cook, Sherman M. Fairchild, James A. Allis (chairman of the board), Charles H. Colvin, E. Ainsworth Eyre, Frank R. Nichols, and Richard S. Boutelle (president). (Courtesy Eloise Shaffer.)

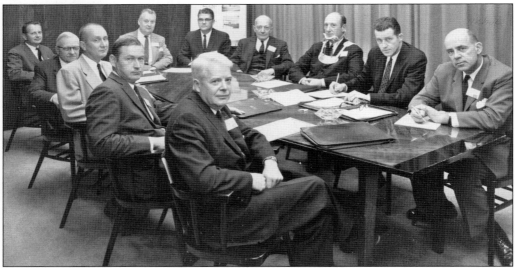

Pictured are members of the board of directors of the Fairchild Stratos Corporation on October 3, 1962. Pictured clockwise from the foreground are Melvin C. Steen (corporation counsel), Walter F. Burke, J. Bradford Wharton Jr., Charles H. Colvin, Edward G. Uhl (president), Sherman M. Fairchild (board chairman), James T. Dresher (vice president/finance), William Preston Lane Jr., Jerold C. Hoffberger, John L. Grabber (secretary), and Frank R. Nichols. Not shown are C. Leo DeOrsey, Ralph S. Stillman, and Courtland D. Perkins. (Courtesy Eloise Shaffer.)

Longtime Fairchild employee Don Revell (left) started working for the Kreider-Reisner Company in 1927 and was one of the company's early pilots. It was Revell who helped secure land near the Hagerstown Airport for the Fairchild plant north of Hagerstown. When World War II broke out, Revell hired his brothers Frank, Carl, and Bonnie to help in the manufacture of airplanes. (Courtesy Colleen Revell Heuser.)

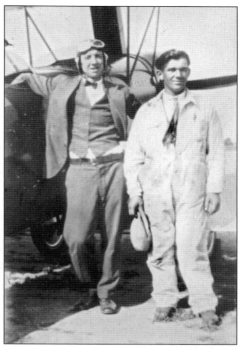

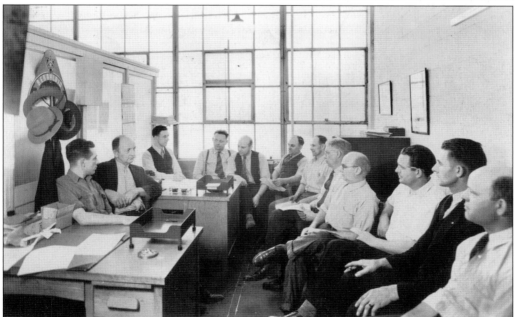

Fairchild's entire production supervisory staff is pictured here in 1935 attending a weekly foremen's meeting. From left to right are M. C. Mummert, Charles South, Don Revell, Ed Buchanan, Charles Slick, Ira Pike, Merle Schindle, Stanley Foltz, Chauncey Travis, K. O. King, Bud Shaw, and Charlie Mullenix. In 1953, Shaw was honored for 25 years with Fairchild and was the number one employee in terms of service, having started with Kreider-Reisner in September 1927. (Courtesy Danny Shindle.)

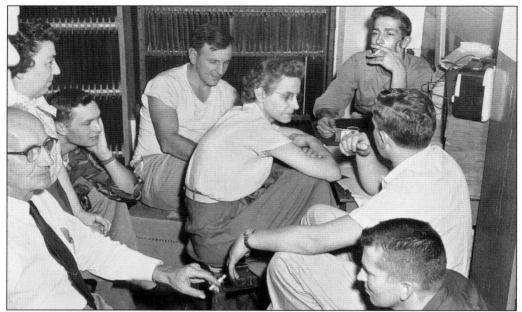

Engineering Photo Lab employees take a break to listen to the World Series around 1950. Pictured are, from left to right, Felix Schneidenhan, Julia Byrd, Floyd Munson, Bob Hoke, Lill Bober, Donald Blickenstaff, Meredith Darlington, and Ernie Young. In 1944, all of Fairchild's Hagerstown-area plants had two 10-minute rest periods for employees. (Courtesy Meredith Darlington.)

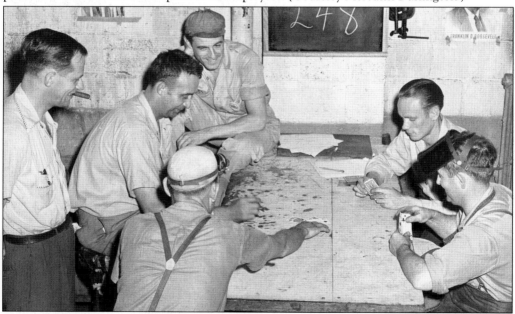

Fairchild Plant No. 14 card sharks take advantage of their rest period for a quick game of gin rummy. Around the table clockwise, starting on the left, are Grant Jackson, Arthur White (cigar), William Derr, Edward Jacoby, Hubert Harbaugh, and Edwin Palmer. Former Fairchild employee Andy Auxt recalls that he and fellow weight lifter Paul Hylan used their rest breaks and 30-minute lunch break to occasionally toss horseshoes. (Courtesy Danny Shindle.)

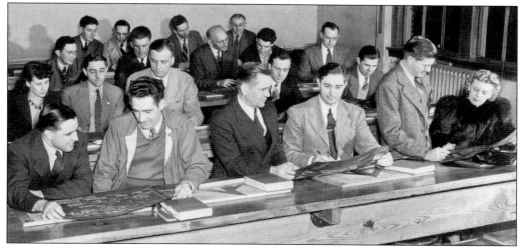

Vernon Alter is seen in the back row, second from the left, in a 1941 blueprint reading class at Fairchild. Alter was hired on August 20, 1941, and retired on August 21, 1984, at the age of 63. Alter started work at Plant No. 1 on Pennsylvania Avenue in Hagerstown as a blueprint machine operator in the Engineering Department. From 1944 to 1948, he worked as a draftsman, and from 1948 to 1984, he was a production planner, a position he held for 37 years. (Courtesy Dave Alter.)

In 1945, nine employees from Plant No. 14 located on East Baltimore Street in Hagerstown were awarded gold service pins to signify five years of service with Fairchild. From left to right are (front row) E. F. Kline. R. Hartman, W. Kerns, and C. L. Martin; (second row) D. Murray, C. Kunkleman, F. Dietrich, P. Younkers, and C. W. Baker. (Courtesy Danny Shindle.)

From left to right, Bob Mull, Meredith Darlington, and Woody Milburn are in the process of producing a photograph template. Located in the Engineering Photo Lab, the machine made such templates by reproducing blueprints on sensitized metal. When Fairchild was awarded a contract to build tooling for the Luscombe Airplane Corporation in 1953, it marked Fairchild's entrance into the field of tool specialization. (Courtesy Meredith Darlington.)

In 1953, members of the Engineering Photo Lab are, from left to right, (first row) Bob Mull, Meredith Darlington, Floyd Munson, and Woody Milburn; (second row) unidentified, John Easterday, Ernie Young, and Bob Hoke. Easterday later served as a Washington County commissioner. Fairchild's Tooling Department at the time was headed by A. D. Jairett, who joined the Aircraft Division in 1945 as chief tool engineer. (Courtesy Meredith Darlington.)

Julia Byrd of the Engineering Photo Lab demonstrates the ease of handling and storing Mylar, an opaque film. By using Mylar, Fairchild was able to realize a cost reduction of 60 percent. Previously six men could make 20 templates a day. With the use of Mylar, however, four men could make 40 templates each day. In 1957, 12 percent of all drawings made in engineering used Mylar. (Courtesy WMR.)

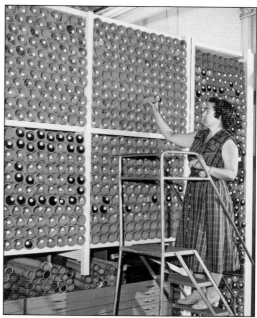

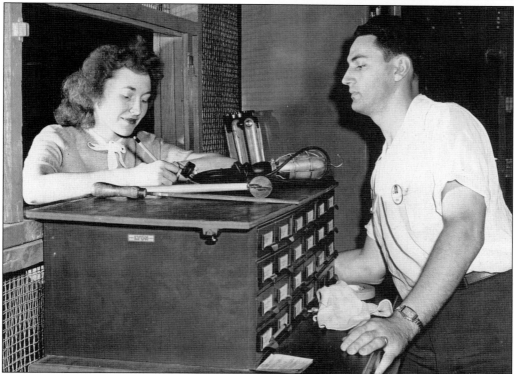

Army veteran Albert Schlotterbeck is seen at the tool crib at Plant No. 2C with Helene Liskey of Department 172. Schlotterbeck began work at Fairchild on July 13, 1939, at the age of 21 and set up tool cribs at Plant Nos. 1, 3, 5, 8, and 13. Later he worked as a tool expeditor before retiring on April 11, 1983. (Courtesy Richard/Gloria Clem.)

Stanley Eckstine is seen working at Fairchild as World War II ended in 1945. In 1943, Eckstine received the Army-Navy E Award for his "personal efforts and contributions towards the production of vital war materials." In a program broadcast locally, 4,500 people assembled in flag-draped Plant No. 2B on February 7 for the award ceremonies for Fairchild employees. Many dignitaries, including Hagerstown mayor Richard Sweeney, attended the event, which also featured the Hagerstown Municipal Band. (Courtesy Leroy Eckstine.)

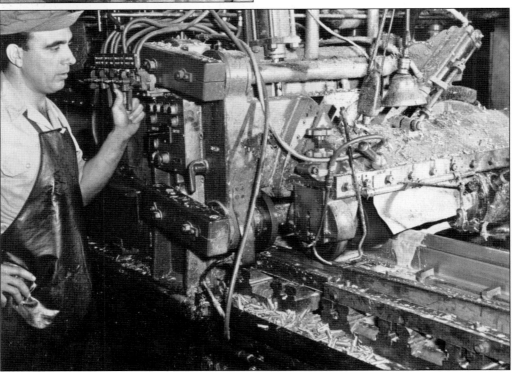

Fairchild employee Carl Zello is pictured working on wing extrusions on a spar mill machine at Plant No. 1. In the early 1940s, Zello was a welding instructor at Fairchild's Plant No. 14, one of the company's facilities used in the manufacture of parts for the PT-19. Zello retired in 1979 after 39 years at Fairchild. (Courtesy Carl Zello.)

Grady Grimm is working on a motor mount for a Fairchild PT-19 in 1941. Grimm, who worked at Fairchild for 22 years, is assembling engine-mount bushings in the photograph taken at Plant No. 1 on Pennsylvania Avenue in Hagerstown. (Courtesy Dave Verdier.)

In March 1953, a B-52 wing and fin production line went into operation at Fairchild. Charles Bitner and Joe Chaney are pictured working on the B-52 rudder component in 1955. Approximately 1,000 Fairchild employees were utilized to fulfill the contract with Boeing Airplane Company in Seattle, Washington. When going by rail, the wing assemblies took 12 days to travel the 3,300 miles between Hagerstown and Seattle. (Courtesy Dave Verdier.)

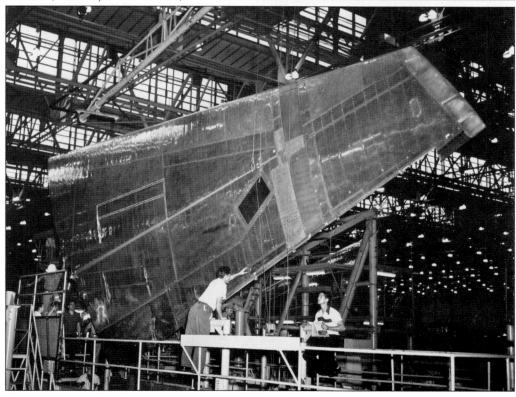

Ivan Ausherman (left) operates a 25,000-pound coordinate setting machine at Fairchild Plant No. 2. The only one of its kind in the world, the machine was designed by Fairchild to reduce the time necessary to set up jigs in which F-27 parts were built to exacting tolerances. Capt. O. S. Reading of the U.S. Coast and Geodetic Survey recommended that Fairchild build the machine, which was capable of setting points of fittings within a few thousandths of an inch in their correct relationship to each other within a maximum range of 100 feet. Pictured below is Max M. Smith, a tool and dye maker at Fairchild. Smith started working at Fairchild in 1936 and retired in 1964 from Plant No. 2. (Left courtesy Ivan Ausherman; below courtesy Richard and Gloria Clem.)

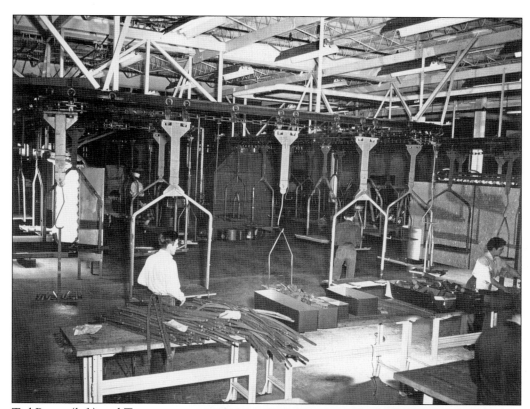

Ted Peters (left) and Tom Murray are seen in the above photograph in the paint shop, Departments 111 and 112, at Fairchild's main plant on Showalter Road in the early 1950s. In the picture at right, Guy Knepper, superintendent of the Tool and Jig Department, is seen second from the right. At the end of World War II, Fairchild went from a six-day, 48-hour week to a five-day, 40-hour week. When general manager R. S. Boutelle made the announcement, he expressed the belief that the reduced workweek would not "affect present high production quotas" and that employees "would maintain the present high quality of their work." (Above courtesy Tom Murray; right courtesy Adaline Knepper.)

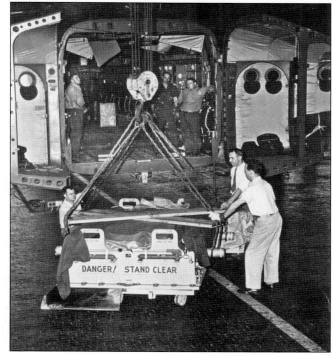

In 1943, ten members of the Blickenstaff family worked at Fairchild. Pictured are, from left to right, Jane Blickenstaff Finniff (Ralph's daughter), Helen Blickenstaff (Robert's wife), brothers Ralph, Henry, Foster, Daniel, Robert, and Milo, Russell Blickenstaff (Ralph's son), and Thomas Blickenstaff (Foster's son). (Courtesy Ernie and Jane Finniff.)

October 18, 1943, was "a date I'll never forget," noted Frances Sheeler Rupp, who went to work for Fairchild at that time. Rupp served as a *FAD* reporter for Works Engineering while at Fairchild and also worked in public relations. Her sister Virginia also worked at Fairchild. As she reflected on her years at Fairchild, Fran Rupp stated, "I have no regrets at all. I had 18 beautiful years. I really enjoyed working there!" (Courtesy Fran Rupp.)

At right is a sketch of "Rosie the Riveter," created by Fairchild riveter Clara Hewett Williams. On one occasion, Williams was riveted inside the fuselage of a plane and had to be cut out. "Now, I was the talk of the plant for months," she laughed. "I loved the changing of shifts, seeing the many people that worked there, especially women—all working together for one cause." (Courtesy Clara Williams.)

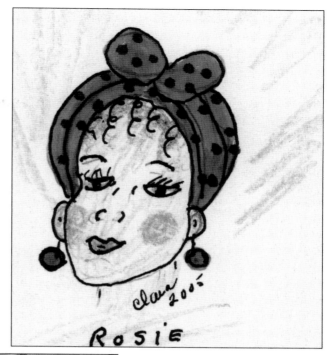

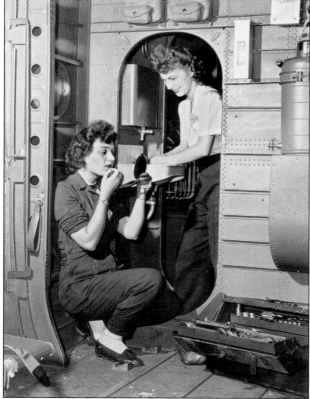

Pauline Rohrer Williams (left) and Madeline Hensley of Department 172 at Fairchild's Plant No. 3 take advantage of one of the special features of the C-82 Packet, a built-in washroom, in this 1945 photograph. When this picture was taken, Pauline Williams's husband, Pfc. Riley Williams, was fighting on Okinawa. (Courtesy Meredith Darlington.)

Jane Strevig Guyton, Miss Hagerstown 1949, greets Miss America, Jacque Mercer, upon her arrival at Fairchild. Mercer and her mother were guests at a luncheon in their honor at Fairchild. After her graduation from Hood College in 1949, Jane Strevig went to work in the Personnel Department at Fairchild's main plant. She laughed as she recalled that it didn't take long for word to spread that Miss Hagerstown was a Fairchild employee. (Courtesy Jane Guyton.)

In the spring of 1950, a trio of ladies from the Tabulating Division take advantage of the warm weather to enjoy their lunch. From left to right are Jane Bowser, June Toms, and Joyce Palmer, who later met and married another Fairchild employee, John Kreigh. She worked for the aircraft manufacturer for 22 years, and her husband worked there for 18. (Courtesy John Kreigh Jr.)

Fairchild employee Andy Auxt (Tool Planning) plays the role of Santa Claus for Leiter Brothers in downtown Hagerstown in this 1949 photograph. Unaware that their father was inside the suit, Erik, Sharon, and Kristin (on Santa's lap) Auxt enjoy their visit with Santa. (Courtesy *FAD*.)

In 1949, a group of Fairchild workers known for their weight-lifting skills donated blood to the American Red Cross. From left to right are (first row) Paul Cump, Carl Zello, Paul Hylan, Charles Pottorff, and Fred Bell; (second row) Andy Auxt, F. Respo, Red Cross nurse Frances Jakobek, D. Toms, and Stewart Brinton. (Courtesy Carl Zello.)

Ellis G. Duffey Sr., whose family was noted for their musical ability, worked in the Experimental Department at Fairchild. The Musical Duffeys are, from left to right, Barbara (Starliper), Miriam (Andrews), Eloise (Miller), Ellis Jr., David (front), and Ellis Duffey Sr. Barbara worked at Fairchild from 1952 to 1959 as a civil service employee for the U.S. Air Force. (Courtesy Barbara Starliper.)

Trucks and their drivers played a vital role in Fairchild's production of aircraft. Drivers were responsible for all interplant hauling, which resulted in 4,011 miles being traveled each week. In 1943, the company's 33 drivers made 200 trips every 24 hours. In the front row, third from the left, is Clarence Ebersole. In the back row, Les Shoemaker is pictured third from the left. (Courtesy Gary Carter.)

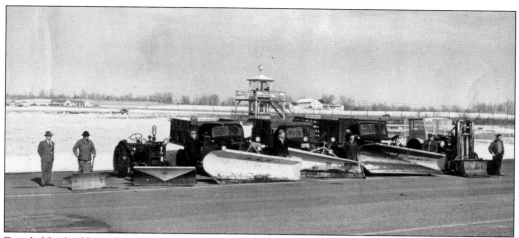

Fairchild relied heavily on its maintenance department, especially in the winter. Charles Holbert reflected on what it was like when snows hit the area in 1949. "The first real job is to clear the runways. The plows work in echelon. Working three plows in echelon, it is possible to move snow from a path of 26 feet on each run. On the north-south runway, we can do the job in four round trips at about eight minutes per trip. On the east-west, it takes 11 minutes each for the six trips. With the runways out of the way, we tackle the taxi strips and the hangar ramp. The boys from the hangar group usually pitch in with us on this job; we call 'em snowplow cowboys. Snow removal is a science . . . the kind of snow, the outside temperature, the weather forecast, wind direction, and even the smell of the atmosphere have their effect on the way we go about the job." Snowplow driver Clarence Ebersole is pictured second from the left in the photograph above. Below, Ebersole kneels third from the left. (Courtesy Gary Carter.)

In 1946, the cafeteria at Fairchild's Plant No. 2, headed by Lee Stine, employed a staff of 59 workers on three shifts. To feed 4,000 workers daily, three whole beefs were bought each week to go along with 700 pounds of potatoes that were consumed at each noon meal. Each day, 55 gallons of soup were prepared for hungry employees, 100 loaves of bread were consumed each day along with 90 dozen buns, and coffee disappeared at the rate of 125 gallons every day. Add to that 46 cases of white milk and 30 cases of chocolate to go along with 20 giant sheet cakes (about 1,000 slices). Pies were baked in lots of 300. In the above 1955 photograph, Pauline Hovis is at the French fryers, Phyllis Trumpower is putting butter patties on a tray, and at right, June Hose is making glazed carrots. In the picture below, cafeteria workers take time out to enjoy their own Christmas party on December 21, 1960. Seated on the left side of the table are, from front to back, June Hose, Gladys Billman, Doris Churchey, Talba Barnes, Stewart Paxton, Pauline Hamsher, and Edith Grey. On the right side are, from front to back, Barbara Shank, Grace Schildtknecht, Mildred Detrow, Catherine Shobe, Viola Wyncoop, Edna Koons, and Betty Myers. (Courtesy Jean Mills.)

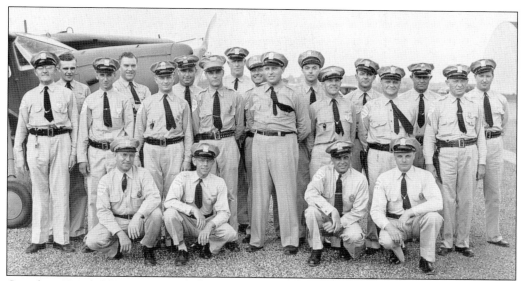

Guards at Fairchild Plant No. 2 are pictured above. From left to right are (first row) Raymond Jones, James Bishop, Raymond Scranton, and Albert Phebus; (second row) Robert Hamilton, Elmer Mills, Elias Whitlock, Lt. Francis Lewis, Sgt. William Randall, Alridge Hardy, William Hammond, and Sgt. Ralph Etter; (third row) Orville Miller, Preston Hartman, Kenneth West, Charles Alkire, Allen Fizer, Heber Swaim, Jack Mock, Sanford Reid, and James Barnhart. (Courtesy Meredith Darlington.)

Fairchild guard Cletus Fizer checks the ID of a fellow employee, Lucien Beam. Asked the most difficult aspect of a guard's job, he replied, "If people aren't trying to lug groceries into the plant, they're trying to slip in without a badge. Some of 'em sure make life hard for me—like the lady who tried to give me a dollar to guard a pound of butter for her, but they're a swell bunch, and I like 'em all." (Courtesy Meredith Darlington.)

Fairchild guard Ollie Mumma is seen in the photograph at left. Guardette A. B. Huyett stated in 1946, "It's amazing the number of odd places people find to wear their badges—from hatbands to shoelaces. It would make my job easier if employees would wear their badges on their left shoulder. Sometimes I think I ought to take up hand-writing analysis to decipher some of the scrawls on the gate passes." In 1942, the War Department sent a letter to Fairchild security personnel, saying, "Our enemies are all around us. Where and when they will strike we cannot know. That they will try to strike at the heart of our production we do know. You men [women] of the Auxiliary Military Police [below] are our interior battle force. Our enemies are tricky, deceitful, smart, and dirty. They are out to wreck us, and they will stop at nothing to do it. . . . They are watching you, every minute you are on the job, waiting to catch you napping. Only by keeping constantly alert can you outsmart them." (Courtesy Meredith Darlington.)

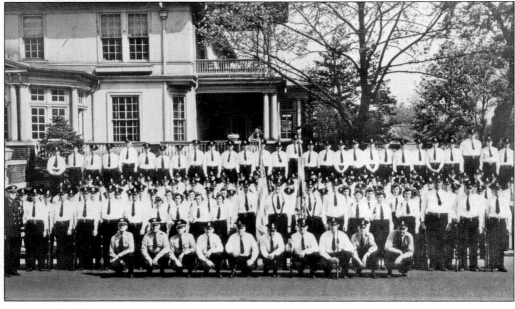

In August 1941, Jacqueline Cochrane, one of the world's foremost female aviators, arrived at the Hagerstown Municipal Airport after a flight from New York. After viewing a Fairchild Model 24, she exclaimed, "Isn't that a love! I'm going to get one when they start selling them three for a quarter. It would be perfect for my ranch since it requires only a small runway." In 1932, Cochrane had become the first woman airline pilot, and in 1953, she became the first woman to fly faster than the speed of sound. (Courtesy Dick McNeal.)

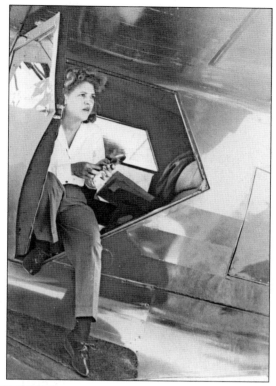

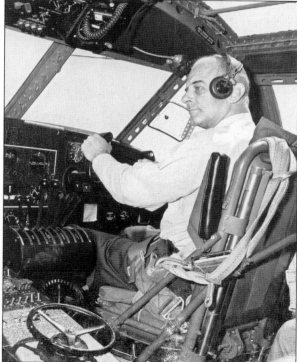

Lt. Gen. James H. Doolittle visited Fairchild in May 1946. Doolittle was the commander on the famed Shangri-la raid over Tokyo on April 18, 1942, and later served as commander of the 8th Air Force in England. Doolittle arrived in Hagerstown in a B-25 for the express purpose of inspecting Fairchild's C-82. After receiving a tour of the C-82 production area, the famed aviator flew one of the C-82 Packets. (Courtesy WMR.)

Bill Rinn, who launched his aviation career with Fairchild in 1950 shortly after his graduation from Hagerstown High School, is pictured on the wing of his Vultee BT-13 trainer in 1952. In 1954, Rinn, who was also a member of the Hagerstown chapter of the Civil Air Patrol, became manager of Henson Aviation and, for a while, served as chief pilot for the company. (Courtesy Bill Rinn.)

Fairchild's chief test pilot, Dick Henson (right), is seen with Lt. Tony Lumpkin during an interview on the nationwide Army Air Force radio show in November 1943. The show was later rebroadcast by Hagerstown radio station WJEJ. In his remarks, Lumpkin praised the Hagerstown System, which incorporated many local businesses into the manufacturing of airplanes. (Courtesy Hagerstown Aviation Museum.)

In the 1950s, entertainer Arthur Godfrey (center) is pictured shaking hands with Fairchild test pilot Dick Henson, who got his start with Kreider-Reisner in the late 1920s in the stockroom and final assembly. Standing at the left is Fairchild general manager Richard Boutelle. After becoming Fairchild's chief test pilot, Henson related that one of his greatest thrills in aviation came from demonstrating Fairchild's PT-19 in competition with other planes at Ohio's Wright Field. (Courtesy Hagerstown Aviation Museum.)

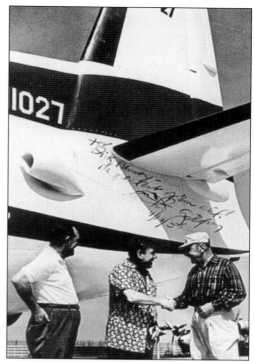

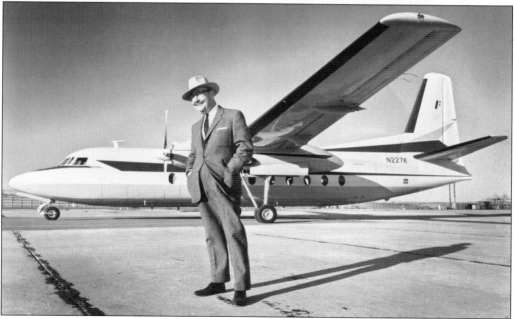

Dick Henson, known affectionately as "The Million Dollar Airplane Salesman," poses with an executive model of the Fairchild F-27. Henson served as a test pilot and flight-test manager for Fairchild for more than 30 years and later become recognized nationally as a pioneer of the air commuter concept, which brought quality airline service to small communities. Henson Aviation eventually became the nation's first commuter airline. (Courtesy Jack King.)

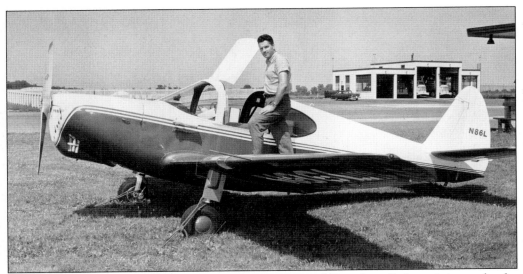

Fairchild pilot Russ Howard got his start in the aviation world by taking flight training under the GI Bill of Rights after serving in the U.S. Navy. After returning to work at Fairchild, Howard bought a Stearman PT-13 biplane to use in his own crop-dusting business. Howard removed the front cockpit and converted it into a spray tank. (Courtesy Russ Howard.)

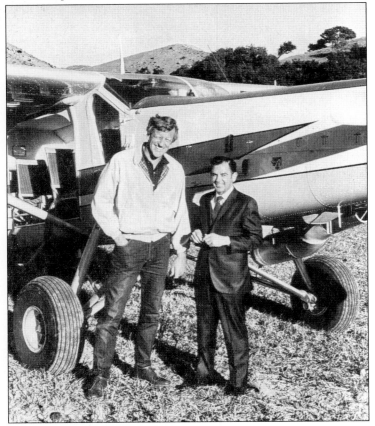

Fairchild test pilot and corporate pilot Al Maye (right) poses in front of a Fairchild Turbo-Porter along with actor James Arness at Arness's California ranch in the late 1960s. Maye received his pilot's license while a senior in high school. After serving in the U.S. Air Force, Maye went to work at Fairchild in July 1947. Maye called flying the Turbo-Porter "real flying. You have complete control. There's no automatic pilot. I can land it on a dime, take off in a flash, and know it won't quit on me." (Courtesy Maye family.)

Fairchild employees Al Maye (left) and Russ Howard converse while attending a helicopter convention in Palm Springs, California. Maye spent nearly 40 years with Fairchild while Howard worked for the company for almost 28 years. Howard logged over 5,000 hours flying Fairchild's C-119, a plane that he described as "a lot of fun!" (Courtesy Russ Howard.)

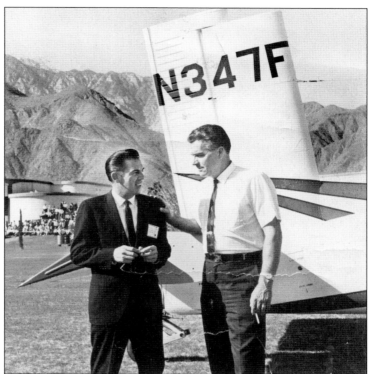

Fairchild pilot Fred Kuhn is pictured while taking Primary Flight Training at Mustang Field in El Reno, Oklahoma, while in the U.S. Army Air Corps. Kuhn received his training at El Reno in a PT-19 built by Fairchild. Kuhn was a bomber pilot during World War II and went to work at Fairchild in 1951 after graduating from West Virginia University. (Courtesy Fred Kuhn.)

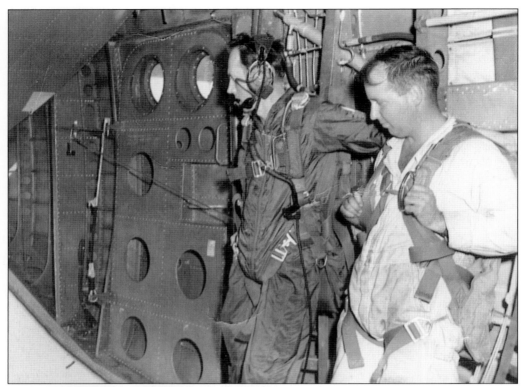

Fairchild flight-test engineer Allen Clopper (left) and crew chief Dick McNeal are seen in a C-119. Clopper recalls that the 30 years he spent at Fairchild were "the golden years of the company. I was in an enviable position—flight test, experimental, in Dick Henson's department, developing test programs for each new model, flying as the engineer to conduct tests, and feeling a team spirit like battle comrades." (Courtesy Dick McNeal.)

The children of Mr. and Mrs. Harry Vollmer III are looking at a C-119 during a Fairchild open house in 1949. From left to right are H. Frederick Vollmer IV, Margot (Vollmer) Bryer, and Becky (Vollmer) Westbrook. The youngsters' father was involved with personnel and public relations at Fairchild. (Courtesy FAD.)

June (Harbaugh) Martz is putting the finishing touches on a heating duct inside one of the tail booms of a C-119 in 1949. The photograph was taken shortly before the boom was lowered into place for assembly. June Martz and her sister Betty Russell went to work at Fairchild on March 17, 1942, at Plant No. 8, located in the Exhibition Hall at the Hagerstown Fairgrounds. (Courtesy June Martz.)

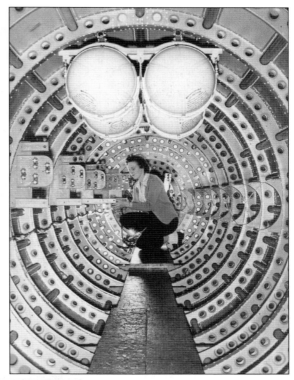

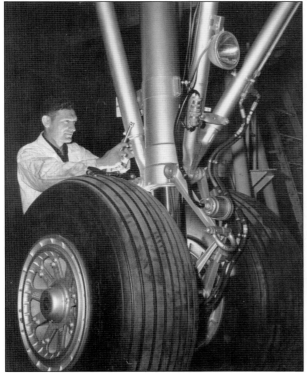

Flight-test worker Izzie Horowitz adjusts C-119 landing gear in 1949. In the same year, Fairchild's employment totaled 4,519, of which 2,358 came from Hagerstown. Other Washington County towns with at least 50 people working at Fairchild were as follows: Williamsport, 141; Boonsboro, 115; Smithsburg, 100; Clear Spring, 80; Sharpsburg, 68; Hancock, 63; and Big Pool, 50. Figures for nearby Pennsylvania communities were Waynesboro, 153; Greencastle, 137; and Chambersburg, 85. (Courtesy Dave Verdier.)

A "Shortcake Party" was held at Fairchild Plant No. 5 on June 1, 1948. John Faulder, Art Beeler, and Fred Smith provided the strawberries, and Russ Henson baked the cake, which was served on a workbench during the lunch break. Sawhorses were used for seating at the "banquet table." (Courtesy Polly Martin.)

Thomas B. Fitz (left) receives his 15-year pin from Orrin Berthiaume in 1953. In 1943, Fitz, who was president of the Fairchild Employees Recreation Association, coordinated a Memorial Day mass prayer meeting at Hagerstown's City Park on behalf of the nation's service personnel. Berthiaume became assistant general manager at Fairchild in 1951. The Seattle, Washington, native joined the workforce at Fairchild as Plant No. 1 superintendent in August 1947. (Courtesy Polly Martin.)

On September 25, 1952, as presidential candidate Dwight D. Eisenhower's motorcade was traveling to Hagerstown from Martinsburg, West Virginia, the future president spotted three C-119s piloted by Fairchild pilots E. R. "Dutch" Gelvin, E. W. Hopwood, and Ott F. Beckner flying overhead. Upon seeing the cargo planes, Eisenhower remarked, "That's a good airplane. We need a lot of them." (Courtesy *Maryland Cracker Barrel.*)

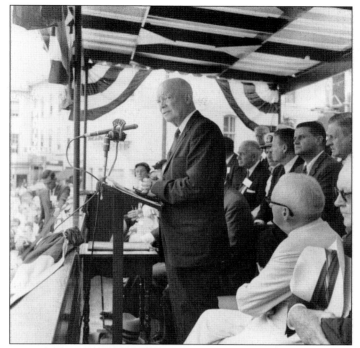

Jack Evans, supervisor of the Blueprint Room in the Engineering Department, is honored at a baby shower by fellow Fairchild employees. Helen Barbara Shank, who worked in the cafeteria, noted, "Raw oysters and shrimp! I remember serving them that day." She also remembers serving Wernher von Braun, a technical adviser to the United States Army at the time. "He was very common—he talked with us. They ate in the executive dining room, which was very plush!" (Courtesy Helen Barbara Shank.)

During a dinner honoring Fairchild Quarter Century Club members at the Hotel Alexander in Hagerstown in 1954, W. L. Landers (right), division general manager, presents a watch to Daniel W. Shaw. Representing Fairchild management are, from left to right, (first row, seated) Charles F. Slick, works manager, and Joseph H. Baylis, director of industrial relations; (second row, standing) charter Century Club members Blair L. Stallings, Lester H. Conrad, Oliver L. Musselman, Daniel Shaw, Charles S. Shaw, and W. L. Landers. (Courtesy Danny Shindle.)

The men who were recognized for their admission to the Quarter Century Club in December 1954, along with their wives, are, from left to right, Mr. and Mrs. Edward L. Buchanan, Mr. and Mrs. Merle Shindle, W. L. Landers (Fairchild representative), and Mr. and Mrs. William H. Cline. (Courtesy Danny Shindle.)

W. L. Landers presents Merle Shindle, foreman of Department 208, with a "Lifetime of Time" Longine Wittnauer watch for his 25 years of service to Fairchild at the December meeting of the Quarter Century Club. In a letter written by L. E. Reisner, vice president of Kreider-Reisner Aircraft Company, Inc., in 1930, it was noted, "This is to certify that the bearer, Merle Shindle, has been in the employ of this company since March, 1929, as Bench Welder." (Courtesy Danny Shindle.)

Charlie Slick, works manager, presents Merle Shindle with his 25-year pin at ceremonies in 1954. Shindle reflected that one of his proudest moments came during the production of the PT-19, which was built from 1938 to 1944. "In one month we built around 190 PT fuselages in addition to 12 F-24 fuselages and at the same time, of course, we were doing our usual work on compression members and landing gear. We were more than glad to have a hand in producing those trainers for the AAF pilots." (Courtesy Danny Shindle.)

Clarence E. Ebersole (second from the right) is being honored for his years of service to Fairchild. Ebersole went to work for the company in July 1941 and retired in October 1982. Ebersole's sister, Anna Louise Ebersole Carter, went to work at Fairchild in 1942 as a riveter. Her husband, Warren, also worked for the aircraft manufacturer. (Courtesy Helen Ebersole and Gary Carter.)

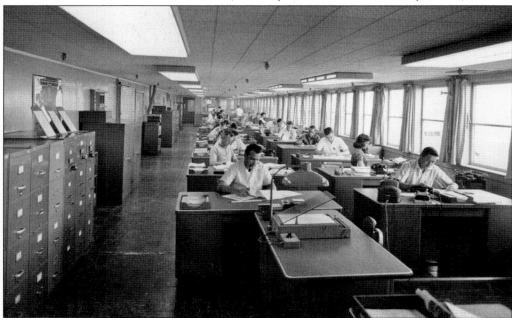

The Flight Test Engineering Department was located on the second floor of Fairchild's hangar building, Plant No. 6. Pictured at far right is Vic Burger. It was in 1944 that the Flight Test Engineering Section was established in the hangar as part of the Flight Test Division. The primary responsibility of the new department was the maintenance, operation, and installation of all equipment used in flight-test operation. (Courtesy WMR.)

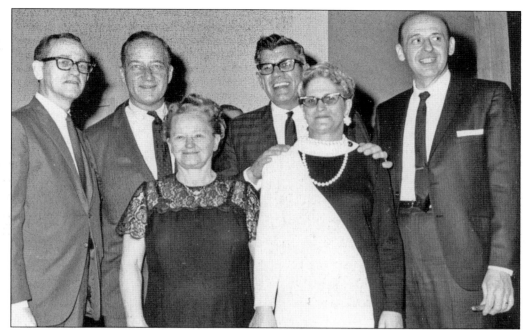

Hester L. Feiser (first row, far left) was given a Certificate of Award from the Par Zero Awards Committee in 1967. The goal of the Par Zero program was to eliminate defects in the manufacture of airplanes. (Courtesy Kathryn Crone.)

Betty Nye, who worked at Fairchild for more than 40 years, is taking shorthand while working with technical writer William Kemp. The Hagerstown resident started work at Fairchild on May 24, 1948, and retired on December 31, 1988. Upon reflecting on her long tenure with Fairchild, Nye stated, "It was interesting to talk to pilots from all over the country and hear their experiences during World War II, missions they flew, and drops they made to the fighting crews on the ground." (Courtesy Betty Nye and Nancy Weirich.)

In 1965, Fairchild senior vice president and general manager James T. Dresher presented 25-year service pins and awards to the following employees in the photograph above. From left to right are (first row) Roger Riggs, Dick McNeal, R. E. Stains, G. F. Cooper, H. Sayers, L. R. Mummert, and H. L. Andrews; (second row) Jack Tritsch, L. M. Crosswhite, K. H. Patterson, B. Byers, J. G. Ernst, C. E. Violet, B. P. Moats, and A. F. Trovinger; (third row) R. L. Diffenderfer. R. W. Stotler, H. E. Hastings, R. L. Green, D. W. Ament, J. T. Hoover, G. K. Hollenbach, C. G. Kountz, C. E. Snook, C. W. Martz, R. D. Boward, and James Dresher. In the photograph below, Cecil Cook (right) is honored for his 40 years of service on November 17, 1976. (Above courtesy June Martz; below courtesy John Kreigh Jr.)

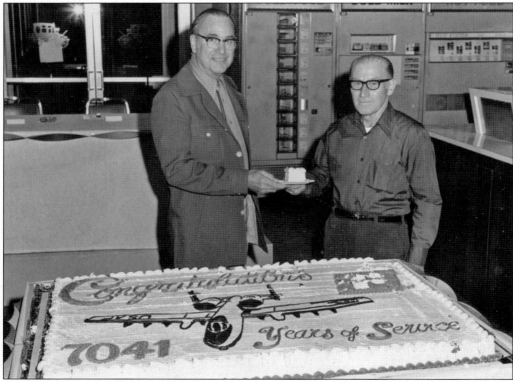

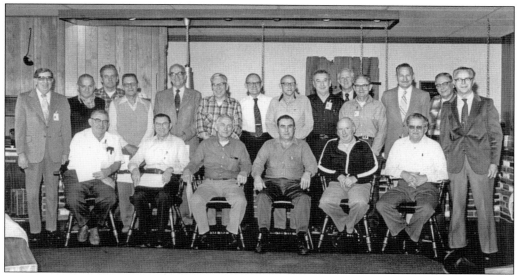

In the photograph above are Fairchild employees who were recognized in July 1980 for their 40 years of service. Seated, third from the left, is Ivan Ausherman, who spent 41 years with Fairchild. In the back row, fourth from the left, is Charles Martz, and pictured fourth from the right in the back row is Gail Mongan. Ausherman gave up a job with the Civilian Conservation Corps in 1940 to go to work for Fairchild. "I made 35¢ an hour on the second trek. When I went to work that night, I thought, 'You get paid for this?' I bolted up center wing panels on the PT-19 trainer." The year 1940 was also special for Ausherman, who married his wife, Ruth Mae, on April 1. "I met her in 1935, but who could get married when you were in the CCC?" In the picture below, Fairchild employees honor Charles Bitner with a retirement party in 1980. (Above courtesy Ivan Ausherman; below courtesy Dave Verdier.)

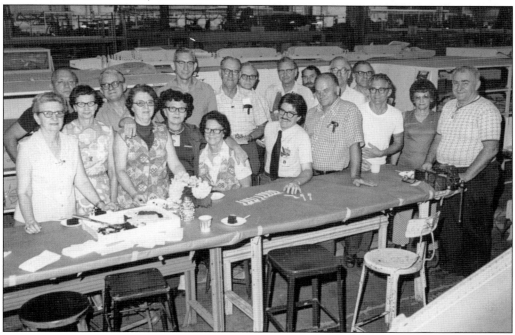

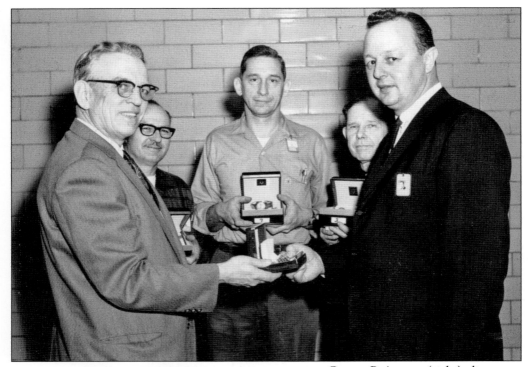

George P. Assmus (right), director of operations for Fairchild, presents watches in 1967 to company workers in appreciation of their 25 years of service. From left to right are Denton G. Shipley, Gilbert T. Hose, Eugene S. Goetz, Gerald G. Bowers, and Assmus. Hose, who started at Fairchild as a riveter and later became a foreman, retired in 1972 after spending 31 years with the company. (Courtesy Jean Mills.)

In 1980, Patricia Ingram was recognized as the Pride and Professionalism Program's Employee of the Month for September. Ingram received the award based on her work performance, integrity, attitude, consideration of others, and sense of responsibility. In recognition of the award, she received a $100 U.S. Savings Bond and an engraved plaque. (Courtesy Jean Mills.)

A Service Award Dinner at Hagerstown's Sheraton Inn in 1985 honored the Fairchild employees pictured above. From left to right are (first row) Bill Bloom (45 years), Rella Koncer (40), and Dick McNeal (45); (second row) Ward Swales (40), Arthur Grimm (40), and Preston Buck (40). After graduating from Boonsboro High School in 1941, Buck took a five-week defense-training course before going to work for Fairchild at Plant No. 8, the Exhibition Hall at the Hagerstown Fairgrounds. (Courtesy Preston Buck.)

Fairchild employees attending a retirement planning lecture on September 27, 1987, are from left to right, (first row) Dusty Routzahn, Barbara Muritz, Don Muritz, Arlene Messersmith, Lois Logan, Bob Logan, and Tom Gargno; (second row) Peter Kline, Don Elliott, unidentified, Dick Messersmith, Tom Ahalt, and Mary Wetzel. Arlene Messersmith retired from Fairchild on March 31, 1988, after 38 years with the company. (Courtesy Arlene Messersmith.)

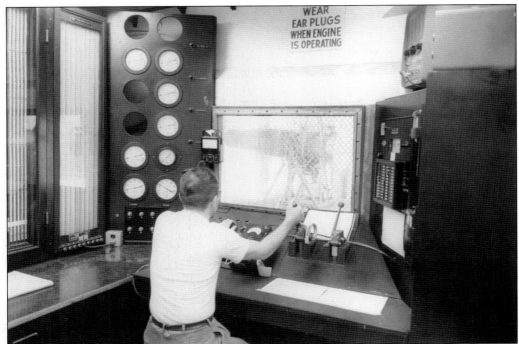

Operator Dean Paulson is running a test on an engine at Plant No. 11, the Jet Engine Test Facility, in the above picture. Among the projects tested here were the Goose and ANUSD-5 drone. In the photograph below, Paul Nally (right) drills holes before insertng buttons into the skin of an airplane. Nally met his future wife, Jennie Suranno, while working at Fairchild. "We went together for one month. We were married on June 22, 1946." Nally recalls watching Fairchild test pilot Dick Henson win a bet when he was able to make one of the wheels on a C-119 touch a building on its approach to the runway near the company's facility north of Hagerstown. (Above courtesy William Wright; below courtesy Paul Nally.)

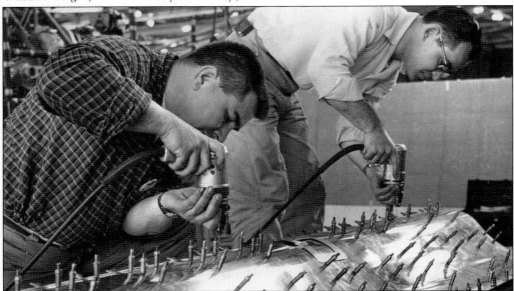

Jacob Gearhart Bemisderfer (right) operates a "drop hammer" at Fairchild during World War II. Large sheets of metal such as aluminum were placed on a mold to be shaped by the drop hammer. Even after Bemisderfer retired with nearly 20 years of service to the aircraft manufacturer, he was called back periodically to work on various complex projects requiring the use of the drop hammer. (Courtesy Virginia Bemisderfer Lawson.)

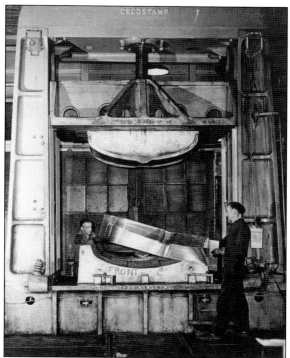

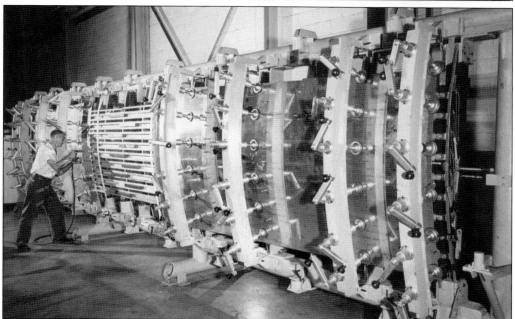

A. M. Moats tack rivets the skin of an F-27 to stringers on the wing center section, upper panel, before Redux bonding in 1957. The process of Redux bonding was one of the unique features of the Fairchild F-27. Developed by Aero Research, Limited, of Duxford, England, Redux bonded metal to metal and was one of the strongest and most reliable bonding processes known in the aircraft industry. (Courtesy WCHS.)

Charles Martz installs wiring and connections in the electrical junction box of an F-27 in 1958. Martz, who worked at Fairchild for more than 43 years, met his wife, June Harbaugh, at Hagerstown's Starland Skating Rink while they were both working at Fairchild. June Martz and her sister Betty both went to work for the company on March 17, 1942, after completing a course in sheet metal and riveting at West Washington Street School in Hagerstown's West End. (Courtesy June Martz.)

Charles Good stands beside a scale model of an automatic riveting machine with a proposed holding fixture for a fuselage assembly. Good, who was a supervisor in Tool Design Engineering, retired from Fairchild in 1983 after nearly 36 years of service. (Courtesy Charles E. Good.)

In 1961, Ed Uhl took over the reins of Fairchild and later became president of the company as well as chairman of the board. A graduate of Lehigh University, Uhl is credited with inventing the Bazooka, a shoulder-fired, antitank rocket launcher. Under Uhl's direction, Fairchild earned the reputation for building the largest, most successful communication satellite ever launched up to that time. (Courtesy Eloise Shaffer.)

In 1972, Dr. Wernher von Braun joined Fairchild as corporate vice president in Engineering and Development. Formerly the deputy associate administrator of NASA, von Braun, on leaving NASA to join Fairchild, stated, "I would like to devote my time now to help implement some space projects. I think I can do this best in private industry where the tools of progress are being made." Born in Wirsitz, Germany, von Braun joined the German Ordnance Department as a rocket development engineer. In 1945, von Braun led a group of scientists to the West, and in that same year, he directed high altitude firings of the V-2 rocket at the White Sands Missile Range in New Mexico. (Courtesy Eloise Shaffer.)

Eloise Troupe Shaffer, a 44-year Fairchild employee, served as a *FAD* reporter. In 1948, Shaffer visited several fashion shops to preview spring fashions and is pictured at left at Leiter Brothers in downtown Hagerstown. Shaffer was hired at Fairchild on February 16, 1944, as a stenographer and played on the company's women's basketball team, the Cargoettes. On one of the team's trips to New York, she received an autographed picture from Fairchild chief executive officer Sherman Fairchild. When Ed Uhl joined Fairchild in 1961, Shaffer became his secretary. In the 1946 photograph below, Shaffer's white straw bonnet is trimmed with a pair of side-grip clamps. Reflecting on her Fairchild career, she commented, "I wouldn't trade my experience or bosses for anything in the world. I seemed to always be in the right place at the right time." (Courtesy Eloise Shaffer.)

The first annual Fairchild picnic (right) was held on Saturday, June 25, 1938, at Cold Springs Park in Waynesboro, Pennsylvania. A program of events included a softball tournament, dodge ball, horseshoes, boys' shoe race, girls' dart throwing, balloon relay, cave man's getup, pie eating, bean relay, word-forming contest, and a peanut scramble. After the success of the 1938 picnic, it was announced that the outing would become an annual event. The second picnic (below) was held at Cold Springs Park on Saturday, July 15, 1939. In the 1940s, the picnic moved to Hagerstown's City Park. For the 1949 picnic at City Park, a crowd of 5,000 employees and their families were expected to be on hand, making the annual Fairchild family picnic the largest in Washington County and one of the largest picnics on the East Coast. In the early 1950s, the crowds swelled to nearly 15,000 persons at City Park. (Courtesy Danny Shindle.)

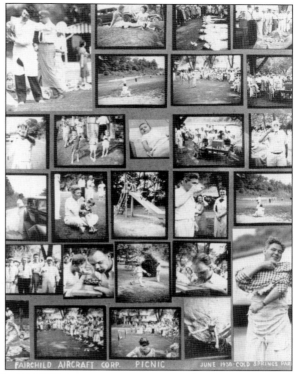

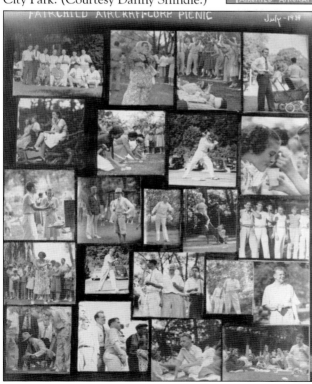

Due to the large number of people attending the annual Fairchild picnics, the event was moved to the Hagerstown Fairgrounds in 1953. Stewart Paxton, coordinator of Employees Services, expected the 1953 picnic to be the largest ever. One of the attractions for the picnic that year was the appearance of professional entertainers Ranger Joe and his Saddle Pals. Annie Staley is presented an orchid by her grandson-in-law Tom Fitz for being the oldest grandmother in attendance in 1953. (Courtesy Polly Martin.)

The Fairchild picnic held at the Hagerstown Fairgrounds on June 30, 1956, featured a circus theme. More than 25,000 people attended the annual event, including Tippy Stringer, television weather girl for Channel 4 in Washington, D.C. Other dignitaries included Maryland senator J. Glenn Beall and Rep. DeWitt Hyde, who crowned Armista Nichols as queen of the picnic. J. E. Sigler was crowned the king by Tippy Stringer. (Courtesy WMR.)

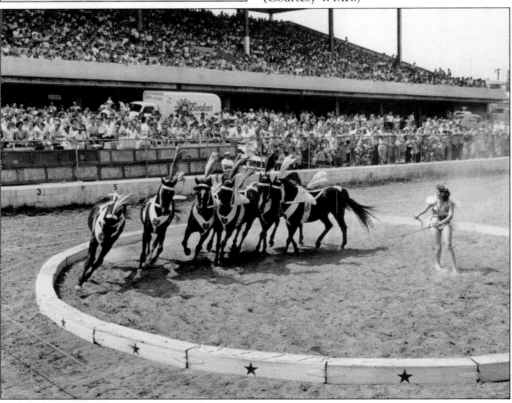

A map of the layout of activities for the Fairchild picnic held at the fairgrounds on July 27, 1957, is seen at right. About 35,000 people attended the picnic in 1954, when western movie star Sunset Carson and a group of Iroquois Indians were featured. One of the main attractions in 1957 was the appearance of "The Great Galosso," the world's outstanding hand-balancing artist, known for his one-finger stand. (Courtesy Danny Shindle.)

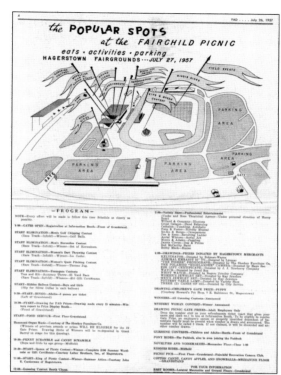

Horseshoes was just one of the activities available for Fairchild employees. When Stewart C. Paxton was appointed the director of recreation for Fairchild Aircraft workers and their families in 1943, his goal was to have each employee take part in at least one sport. Nearly two dozen activities were available, ranging from the traditional sports of basketball and softball to pistol shooting and archery. (Courtesy Polly Martin.)

Pictured above on the wing of a C-82 Packet are the Fairchild Cargoettes, coached by Stu Paxton in the mid-1940s. The women, who were all employed by Fairchild, won the Southeastern District Championship in the 1940s. Pictured are, from left to right, Betty Myers Russo, Lucille Banks Waltz, Peg Wine Weaver, Eloise Troupe Shaffer, Madeline Martz, Jean Cornelius Reynold, Mary Cornelius Peterson, Martha Kitzmiller Froehlich, Jeanne Gearhart Anderson, and Frances "Shorty" Diehl. Below is the Cargoette team that played together in the 1955–1956 season. Players are, from left to right, Shirley Corbin, Helen Gossard, Alice Younker, Amy Myers, Lorrain Warren, Barbara Starliper, Rhoda Helmintoller, Jean Kline, Gloria Burger, and Kathryn Remsburg. This team, which went undefeated, was also coached by Stu Paxton. Following the 1945 season in which the Cargoettes won 26 out of 28 games, the team visited Rockefeller Center, where they were greeted by Fairchild president J. Carlton Ward Jr. and Fairchild chairman Sherman Fairchild. (Above courtesy Eloise Shaffer; below courtesy Barbara Starliper.)

Fairchild tennis champion Roy Lessard meets with members of Fairchild's first female tennis club in 1948. From left to right are Eloise Shaffer, Peggy Wine, Nan Middleton, Roy Lessard, Pearl Miller, and Lucille Sloan. The club was open "to any woman employee who thinks she could wield a racquet." (Courtesy Eloise Shaffer.)

One of the more popular sports activities at Fairchild was bowling. At an awards banquet are, from left to right, two unidentified, Don Jones, Clifford Grimm, Norman Morin, Clarence Fearnow, and Al Schlotterbeck. Both men and women competed in respective leagues. In the women's league during the 1940s, competition was held at the Hagerstown YMCA. At the same time, the men met at Raney's Coliseum. (Courtesy Richard and Gloria Clem.)

Following the 1944 softball season, managers of the FERA league named the All-Star squad. Members from left to right are (first row) Bob Hogan, Al Schlotterbeck, P. Jones, John Salvatore, and Earl Knott; (second row) Pete Moler, "Snuffy" Showe, Alex Browning, Buddy Barnes, Jack McKensey, and Lester Kendle. Those not pictured who also made the team are E. Barr, Calvin Drenner, G. Anderson, Paul Wood, Tom Fitz, and J. P. Wilcox. Hogan and Knott were named comanagers. (Courtesy Richard and Gloria Clem.)

Fairchild workers playing for Fairchild's Plant No. 14 softball team in 1945 are pictured above. From left to right are (first row) Winston Kerns, Bruce Moats, Red Peterson, Buddy Barnes, Al Barkdoll, Charles Kunkleman, and Alex Browning; (second row) H. Jones, Fred Hammer, W. Spade, E. B. Hartle, Fred Dieterich, and Russ Barkdoll. (Courtesy Danny Shindle.)

In the 1948 FERA Softball League, the Twisters captured the first-half championship but lost the season title to the Plant No. 3 All-Stars in a three-game playoff. Members of the Twisters from left to right are (first row) ? Shad, Alex Browning, Buddy Barnes, ? Tritch, and Gene Hoffman; (second row) Ellis Jones, Norman Morin, Jacob Sigler, Charlie Hause, and George Staley. Not pictured are Donald Jones, Alex Alexander, and ? Samsal. (Courtesy Danny Shindle.)

The Plant No. 1 softball team captured the 1950 championship in the FERA Softball League. Pictured are, from left to right, (first row) Hic Browning, Alex Alexander, manager Don Jones, and Ellis Jones; (second row) George Staley, Paul Jones, Al Schlotterbeck, Red Cassidy, Gene Hoffman, Guy Bailey, and Bobby Borst. Not pictured are "Skeeter" Forsythe and Ralph Ganoe. The youngsters in the foreground are Allen Alexander and Charles Hoffman, who served as batboy and mascot respectively. (Courtesy Danny Shindle.)

Harold L. Price is pictured pumping gas at his Amoco service station in the 800 block of Pennsylvania Avenue in Hagerstown near Fairchild's Plant No. 1. Price's son Harold H. is watching the action at the station, which was a popular stop for many Fairchild workers in the World War II era. (Courtesy Harold H. Price.)

The Hagerstown Airport, home of Henson Aviation, is pictured above. In the early 1960s, Henson Aviation was one of 15 commuter services in the country known as third-level operators, which were small commuter airlines. In 1954, Bill Rinn became manager of Henson Aviation and worked for the company until 1966. In the background is the Airport Inn, which was bought in 1961 by a young Greek immigrant, Nick A. Giannaris. (Courtesy Bill Rinn.)

Former Fairchild engineer Bill Curtis (right) talks with an A-10 pilot at an air show in Lancaster, Pennsylvania, in 2004. Curtis was involved in the aerodynamic design of the A-10, which has played a key role for Allied forces in the Gulf region in recent years. The aircraft was the first U.S. Air Force plane designed specifically for close air support of ground forces. (Courtesy Bill Curtis.)

In the 1950s, Fairchild decided to diversify its Hagerstown operation to include the manufacture of aluminum boats. Merle Barnhart was assigned as the project manager for the venture. Each side of the boat's hull was formed from one piece of aluminum and welded together at Plant No. 1 before being sent to Plant No. 2 for final assembly. The Fairchild boat passed all tests with flying colors, but the project was abandoned in the early 1960s. (Courtesy Merle Barnhart.)

Fairchild's involvement in Hagerstown and Washington County included participation in Hagerstown's annual Alsatia Mummers Parade. Pictured above is the company's float, which featured a PT-19 in the 1939 parade. Richard S. Boutelle, general manager of the Fairchild Aircraft Division, pointed out that "no industry can remain apart from the community in which it exists." In 1946, he noted that 33 percent of Washington County's World War II veterans worked at Fairchild. (Courtesy Danny Shindle.)

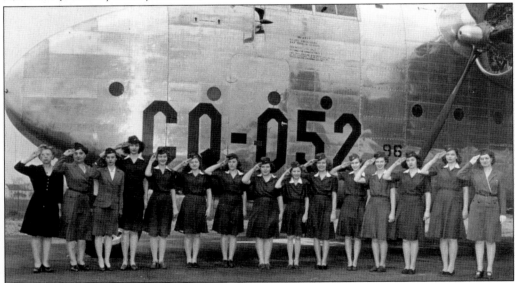

Upon completing a six-month course on the principles of aviation, members of Girl Scout Troop No. 20 became "Packet Wing Scouts" in 1947. The women elected to identify their troop with the C-82 Packet, which is seen in the background. Pictured from left to right are Marja Zimmerman (Girl Scout board), Hattie Carter (Girl Scout board), Catherine McCullough (Girl Scout executive), Marion Foote, Betty Lou Sinn, Lois Snyder, Jane Baker, Lorraine Householder, Barbara Spigler, Pat Spessard, Joanne Grimes, Bobby McSherry, Margy Foote, Janet Rogers, and Henrietta Sinn (leader). (Courtesy Betty Lou Rinn.)

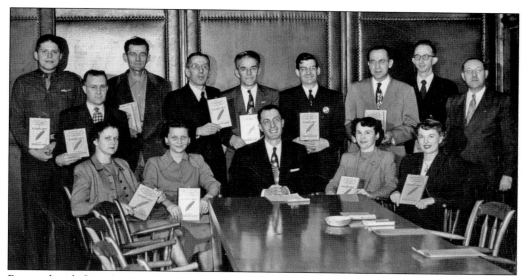

Pictured with Sam Angotti (seated at the table in the center) is the Fairchild Employees Steering Committee, which was responsible for coordinating the company's effort for the Washington County Community Chest in 1950. Seated at the right is Eloise Troupe Shaffer, representing payroll and administration. Standing at the right is Stewart C. Paxton, company chairman for the drive. (Courtesy Eloise Shaffer.)

Pictured at right is Dan Frankforter, chief of Fairchild's Photographic Department. A 1933 graduate of Waynesboro High School, Frankforter joined the Fairchild staff in 1942. His photographs of Fairchild-manufactured aircraft appeared in publications all over the world. Frankforter died suddenly in 1955 at his home in Waynesboro, Pennsylvania, at the age of 40. Ironically, his career with Fairchild began when the C-82 Packet was being built and ended with the completion of the last C-119. (Courtesy *Pegasus*.)

NAME IT

FOR A $25.00 WAR BOND · · · SEE PAGE 2

Vol. 1	February, 1943	No. 1

FAIRCHILD AT-14

Published Monthly by and for Employees of Fairchild Aircraft Division

Pictured above in February 1943 is the cover of the inaugural issue of what would become the *FAD* (Fairchild Aircraft Division) magazine. *FAD* became Fairchild's third employee publication, having been preceded by *Louver* and *Pegasus*. The need for a publication dedicated to the company's Hagerstown facilities arose when Fairchild Engine and Airplane Corporation in New York took over the *Pegasus*. *FAD*'s primary goal was "to service Fairchild Aircraft workers in every possible way." In that initial *FAD* in 1943, workers were encouraged to submit names for their new magazine with a $25 war bond awarded to the one submitting the winning entry. From the many entries, nine individuals recommended the name *FAD*, which was chosen by an overwhelming majority of the editorial board of *FAD*. Instead of awarding nine war bonds, the editorial board gave each of the winners $10 in stamps. The winners were J. K. Bearinger, G. Brown, R. B. Carpenter, H. Darlington, R. G. Hebb, C. K. McLaughlin, B. A. Rupert, M. R. Saylor, and H. D. Teal. (Courtesy *FAD*.)

A Fairchild-built C-82 Packet is about to touch down as it returns "home" on Sunday, October 15, 2006. It was on September 10, 1944, when a C-82 made its first flight at Hagerstown according to J. Allen Clopper, who turned out the test flight report for the plane. That first flight was supposed to be a taxi run, but to the surprise of many, the C-82 became airborne. Clopper, who witnessed that initial flight, was on hand to see the return of a C-82 in 2006, reportedly the last airworthy plane of its type. The aircraft was purchased by the Hagerstown Aviation Museum at an auction in Graybull, Wyoming, on August 23 and flown back to the Hub City. The three-man crew consisted of pilot Frank Lamm of Gainesville, Virginia; copilot T. R. Proven of Haymarket, Virginia; and flight engineer Jack Fastnaught of Columbia, South Carolina. The newly formed Aviation Museum will include a memorial to the more than 50,000 men and women who worked at Fairchild over the years. (Courtesy Frank and Suanne Woodring.)

ACROSS AMERICA, PEOPLE ARE DISCOVERING SOMETHING WONDERFUL. *THEIR HERITAGE.*

Arcadia Publishing is the leading local history publisher in the United States. With more than 3,000 titles in print and hundreds of new titles released every year, Arcadia has extensive specialized experience chronicling the history of communities and celebrating America's hidden stories, bringing to life the people, places, and events from the past. To discover the history of other communities across the nation, please visit:

www.arcadiapublishing.com

Customized search tools allow you to find regional history books about the town where you grew up, the cities where your friends and family live, the town where your parents met, or even that retirement spot you've been dreaming about.